W9-CFT-890

In the same series:

The Louvre
Musée d'Orsay
The Impressionists
Picasso
Matisse
Contemporary art
Paris

This work has been published in collaboration with the educational services
of the Musée National d'Art Moderne and the Éditions du Centre Pompidou.

KEY ART WORKS

Modern art
MNAM-CCI
Georges Pompidou Centre

Christophe Domino
Translated by Cynthia Liebow

EDITIONS
SCALA

All works reproduced in this book are from the MNAM,
unless a different source is given.

To the reader

With this series, KEY ART WORKS, we are proposing a new approach to art. In an analysis of twelve successive paintings, we will try to follow and understand the development of painting as it is represented in a museum.

The fifth volume in this collection, *Modern Art at the MNAM* (Musée National d'Art Moderne) – *Georges Pompidou Centre*, guides the reader, in twelve selected paintings, through one of the richest collections of modern art in the world, twelve paintings selected to bear witness, through precise examples, to the most important preoccupations of the painters of this century.

The museum's history traces the development of a museum of living art, from its beginnings in the Luxembourg Gardens to its current home at Beaubourg.

The introduction explains how, reflecting in this attitude the modern world itself, painters and sculptors were to abandon the rules and norms, taking liberties that would culminate in an explosion of modern art.

The tour through the twelve selected paintings, organised under five "headings" (colour, form, materials, object, image) raises some essential questions about works that have played a significant role in the transformation and development of pictorial art in the 20th century.
At the end of the book, several appendices provide some indispensable information:
– a chronology presents the important artistic trends and movements throughout the world from 1860 to 1960;
– biographical notes give useful information on each of the twelve painters;
– a glossary explains and defines the principal technical terms.

The Georges Pompidou ▶▶
Centre in the middle
of the Beaubourg
neighborhood; in the
foreground, the church
of Saint-Merri.

A 15,000-ton steel vessel
with three underground
floors and seven levels
above the surface, 45 meters
above the ground.

Table of contents

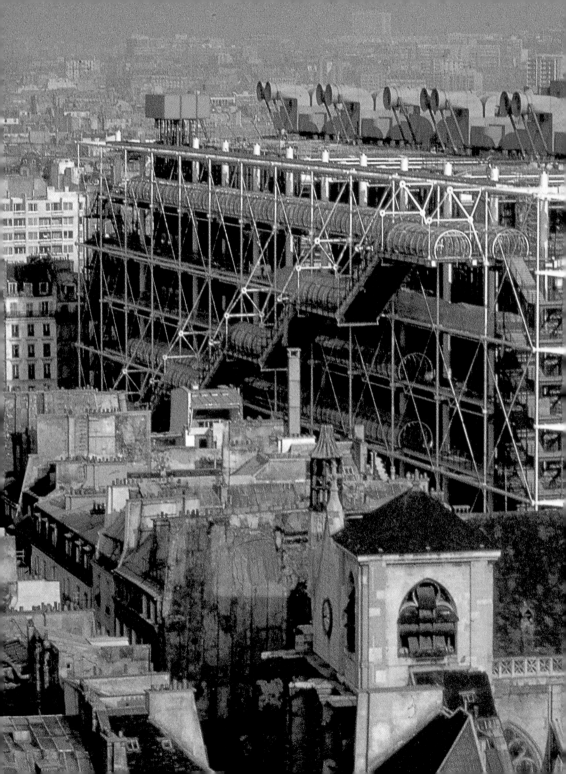

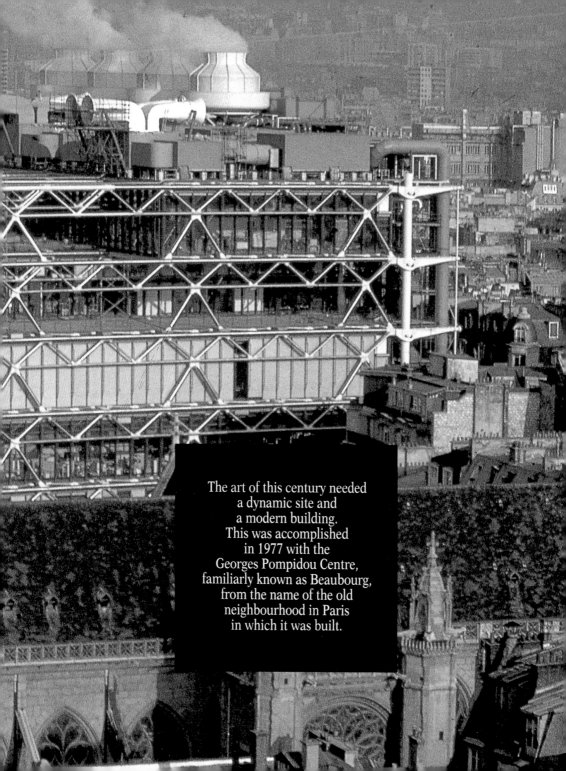

The art of this century needed
a dynamic site and
a modern building.
This was accomplished
in 1977 with the
Georges Pompidou Centre,
familiarly known as Beaubourg,
from the name of the old
neighbourhood in Paris
in which it was built.

While the Musée National d'Art Moderne is one of the most important modern art museums in the world, the collections it houses have a history that is over a century artists. In a century and a half of transformations and changes of location, an extraordinary choice of works, representative of their times, was gradually constituted.

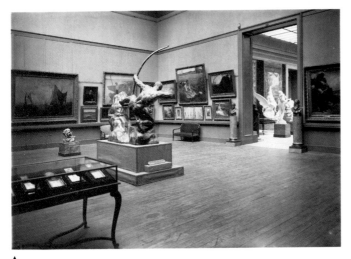

▲
An inner room of the Musée du Luxembourg; in the centre, Bourdelle's *Héraklès* (1900).

In the Musée du Luxembourg, works are exhibited in rooms with often inappropriate or inadequate lighting, overcrowded rooms with paintings hung too close together for today's tastes and habits.

and a half long, a story which began in 1818 when Louis XVIII decided to devote the museum in the Luxembourg Gardens to works of contemporary

And the original vocation of the museum, meant that it was constantly changing and renewing itself, as was the world around it.

1818: The Musée du Luxembourg.

The old royal Musée du Luxembourg, near the Senate in Paris, was thus given the role of receiving the works of living artists. As early as 1822, paintings by David, by Delacroix, by Ingres were exhibited there. Foreign artists did not, in principle, have a place here, however. The museum soon became a showcase of official art, and was not very receptive to novelty. Manet and the Impressionists had a long wait before their works were granted entrance. Public debates, polemical pamphlets and the odd scandal punctuated the museum's history. A place where works only passed through temporarily, it nourished the collections of the other national museums like the Louvre.

1922: The Musée du Jeu de Paume.

Reserved for foreign works, the museum opened to the public in 1932. Here was a museum with a much more modern spirit: the first Picasso was accepted here in 1933, and a Kandinsky in 1937. But foreign museums were still a step ahead. In 1991, the Musée du Jeu de Paume, completely transformed, once again became a museum of contemporary art.

1937: The Palais de Tokyo.

Constructed for the World's Fair of 1937, the building houses two distinct, rival

10

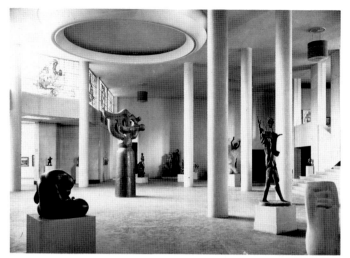

◀ Sculpture room in the Palais de Tokyo.

Despite a somewhat formal construction, not very well suited to the exhibition of works of art, the Palais de Tokyo facilitated a gradual development in the habits and tastes of the museum's curators and of the public.

museums. The State's collections of modern art are presented alongside those of the City of Paris, under the name of the Musée d'Art Moderne (MAM). After the uncertainties of the war years, starting in 1947 this became the Musée National d'Art Moderne (MNAM) and began organising exhibitions on an international scale, which helped to open minds and interest more people in modern art.

1977: The Georges Pompidou Centre.

In keeping with its ambitions, the museum modernized and moved into a new space, in the Georges Pompidou Centre. It regained its title as one of the most prestigious museums in the world for 20th-century art (the Musée d'Orsay now concentrated on 19th-century art) and for the ongoing production of contemporary artists. Given the publics welcome increase in interest for the visual arts, the MNAM must constantly reflect on its direction and development.

2000: The modern century, and the future.

History likes round figures: the end of the century will see the museum's activities and exhibitions taking up ever more space in a renovated building. Twenty years and 144 million

Central aisle of the 4th floor of Musée ▶ National d'Art Moderne in 1986.

Over 150 meters of, the creation, innovation, and sensations of more than ninety years. In the foreground, *Le Cheval majeur* (1914) by Raymond Duchamp-Villon.

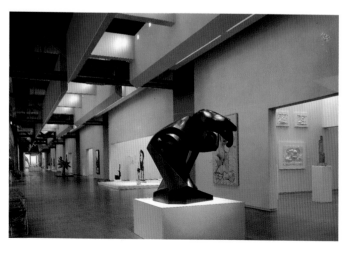

11

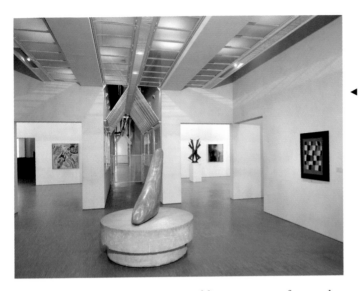

◀ The remodelling of the interior of the museum in 1985 by the Italian architect Gae Aulenti made it possible to rhythm the historical part of the collections and to emphasise similarities, passages from one work to another.
Salle Kandinsky, on the left; *En rythme* (1930) by Paul Klee on the right-hand wall; *The Seal* by Brancusi (1943) on its circular base.

visitors after its opening, any museum would have to be vigilant to resist the wear and tear of time; all the more so an institution like the Pompidou Centre, which contributes to the culture of its times. This is a culture in perpetual transition, in response to both the appetite for novelty and constant redefining of art and creation, as well as to transformations in society and the expectations of the museum's visitors. Don't we speak, and rightly so, of a "culture industry" as an answer to the need for a democratisation of art and an increased public awareness of art and creation? The Centre remains a subject of controversy and of debate over what its role should be – which only goes to prove its importance! Thus the turning point represented by the year 2000 represents an occasion for the remodelling of the presentation rooms of the contemporary collections on the 4th floor. It should be noted that since the museum came to the Pompidou Centre, its collections have grown on a large scale. The inventory shows at least a

The reserves in the depths of the basements no longer suffice! It was necessary to find new locales for storage, sometimes even outside Paris. Here, sliding grills for the paintings. ▶

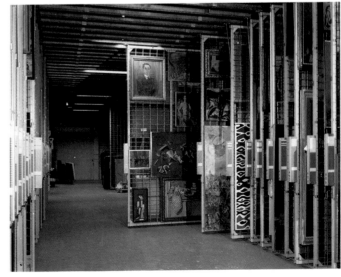

thousand new pieces a year, whether through purchase, gift or donation. And all the more so as various collections have been opened to new domains recently integrated into the museum: ones); and cinema. All this constitutes nine collections, representing 45,000 works of all types, produced by nearly 4,500 artists. The historical collection (1905–60) remains the largest, with nearly 18,000 works, and there are more than 12,500 photographs in the photography department. 700 videocassettes, 35 multimedia works and installations, CD-ROMs

▲
Through the remodelling, the museum wants to remain open to the outside world, to the night, to the city. For a museum of the modern century must know how to be welcoming, to be a place of life.

for example the collections of the CCI (Centre for Industrial Creation) which contains works in the fields both of industrial design and of architecture; photography; the new media (videographic works or numeric-based 5,000 paintings and 2,000 sculptures, the contemporary collection (from 1960 on), contains 1,571 works (a 1997 figure) of all sorts (painting, sculpture, but also all kinds of mobiles, constructions, arrangements, objects, textiles...). The department of graphic arts, which conserves everything relating to drawing since 1905, counts, in and of itself, and audio-visual projects, or projects relating to the new technologies, comprise the new media sector. 730 artists' films, 331 models and 2,246 architectural drawings, 1,554 works of historical "design" (relating to Constructivism, or the Bauhaus, for example), or by contemporary artists. In just the part that is open to the public, the collections take up 14,000 square

▲
The terraces and walkways are also inhabited: here, Max Ernst's *Le Capricorne* (1948) and, in the background, Joan Miró's *The Spirit of the Bastille,* photographed in 1991.

meters; they are continually re-hung and rearranged to accommodate new additions. The museum's documentation, with more than a million documents, constitutes an indispensable archive which records for history the combined works: catalogues, photographic documentation, but also manuscripts and correspondence, all helping to demonstrate how

145 million visitors have come this way ▶ since 1977: the Forum of that time has today been completely remodelled.

the intelligence of art is developed. The role of reflecting on the contemporary world, which remains the central task of the Pompidou Centre, also determines the logic of the exhibition, conference, special event and production schedules, all of which henceforth have redesigned and refurbished spaces. The architect Renzo Piano sees the remodelling of the ground floor as the means of creating a forum with the dimensions of a "cathedral within the little city of the Centre." For a cultural space should also be a place of life, and remain connected to the

outside world, the street. The loan of works and travelling exhibitions are still other ways of contributing to the promotion of culture. 1,500 works travelled in 1989; in 1997, there were 2,400 that left for French or foreign exhibitions. Packing, transport, archiving, restoration: such are the unseen activities of a large museum, which take place in the wings, and which here are located close to another important sector of the Centre: the BPI, or Public Information Library, which has room for 1,800 readers, with access to 500,000 works and all sorts of documents,

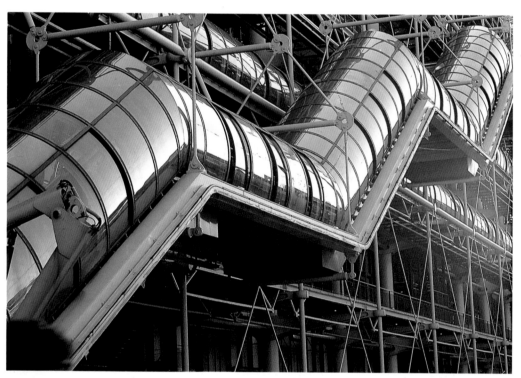

like those accessible on the 400 consultation terminals; IRCAM, a centre for research and creation of contemporary music; and the department in charge of conferences, education, publishing... indeed, it is a little city, where a thousand staff members live, is visited every day by an average of 25,000 visitors. Somewhere in between temple and department store, part school, part leisure-time distraction, the Pompidou Centre cultivates a dream: putting the works of the century within the reach of anyone who gives himself the trouble to try and find them.

The twelve works/chapters in the following pages, along with many of the others mentioned, are among the 900 or so works visible in the showrooms, always a bit outside of ordinary time, on the 5th floor. But also, in a more "virtual" manner, they can be found on CD-ROMs and, better still, online at http://www.centrepompidou.fr.

▲
The caterpillar containing the long escalators is one of the features of this building, which placed all means of circulation outside, in full view, creating a unique vision of a façade composed of pipes.

Pierre Bonnard
(1867–1947),
Studio with Mimosa
(1939–46).
Oil on canvas:
127.5 x 127.5 cm.

The yellow of the flowers
has replaced the light of
the sun. The outside world
invades the studio, and
the painting itself.

Otto Dix
(1891–1969),
*Soldiers Advancing
in the Night* (1915).
Chalk on paper:
28.3 x 28.5 cm.

The First World War
reminded artists of the
horrors of the world. Otto
Dix, a German Expressionist
painter, brought back cruel
visions of it.

▼

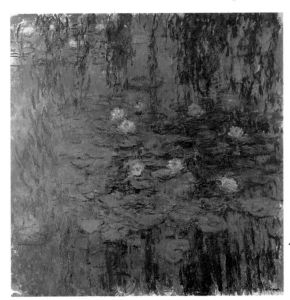

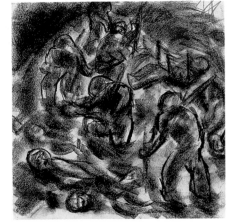

◄ **Claude Monet**
(1840–1926),
The Blue Water Lilies
(after 1917).
Oil on canvas:

200 x 200 cm.
Musée d'Orsay, Paris.
Like the surface of
the water, the canvas
is a flat surface.

The 20th century and its art

Modern art is the reflection of its century: it vehicles profound transformations, changes in centres of interest, on the part of both the artists and the public. Modern painting is no more nor less complicated to understand than that of earlier periods. But paintings of older times answered to different functions: religious art had the role of representing the divine, court art that of flattering those in power. The rules of the game were more or less fixed, evolving slowly. 20th century painting, on the other hand, broke determinedly with all traditions. The rift began in the 19th century, when the Académie pushed to a maximum the norms and regulations which painting was supposed to follow. Numerous artists could no longer tolerate these rules. They wanted liberty and ... they went after it. They broke with conventions, one after another, and each discovery led to a new one.

The militants of this aesthetic revolution were named Monet, Manet, Cézanne, Gauguin and Van Gogh. Thanks to them, a wider and wider public began to be aware of the new questions facing painters and painting.

Around them, life was changing too, faster and faster, as the 20th century began to unfold. Science, technology, machines transformed the relation to reality, to a world that was no longer perceived in the same way. With the telegraph, the automobile, the aeroplane, the earth began to shrink. The globe was becoming an overpopulated village, every remote corner of which seemed to have already been planted and tilled. People began to look further afar, towards the sky, the stars, infinity itself. They learned to see new things in matter, in the secret of molecules, and the infinitely small. One must bow to the facts: with the 20th century, the three dimensions of daily life – length,

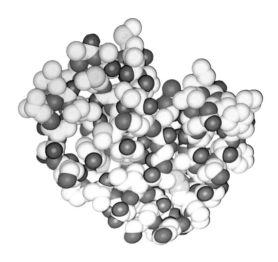

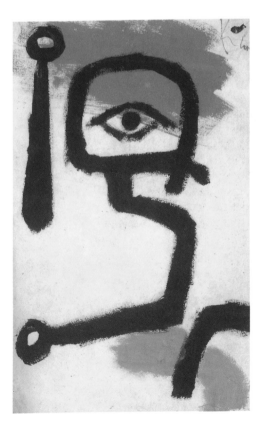

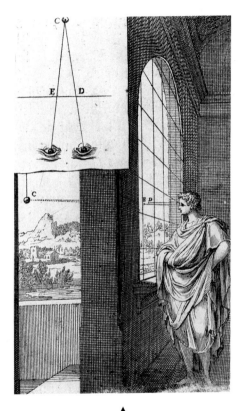

◄ *Protein molecule*
Synthetic image.

The representation
of this microscopic
molecule was
designed by a computer.
Painters are no longer
the only ones in our
century to make visible
what had always been
invisible before.

◄ **Paul Klee**
(1879–1940),
The Timpanist (1940).
Distemper on paper:
34.6 x 21.2 cm.
Kunstmuseum, Bern.

The eye is the prime
tool of the painter:
Paul Klee reiterated
this principle in his
last works.

▲
Engraving from *Discours
touchant le point de vue*
("Remarks on Perspective")
by Sebastien Le Clerc,
printed in 1679.

The window,
the painting, surface
and depth are traditional
elements of the scholar's
reflection on the subject
of perspective.

width, height – were no longer sufficient to account for everything we knew. Space and time were transformed, our vision of the world expanded, reality transcended: the façade of appearances had been shattered.

Nonetheless, the artists of the Renaissance used these three central dimensions as a starting point from which to develop the principles of perspective, some four centuries ago, bringing an end to the flat, demonstrative images of the Middle Ages. The observer accepted, without even realising it, the fiction of painting, the imaginary depth of the canvas. But now, in the 20th century, as the dimensions of the world exploded, painters once again sought out other fictions, other spaces.

They were all the freer as, from around the middle of the 19th century, photography had begun to assume a role which was traditionally a central feature of painting: that of representing and imitating the visible. Photography does this so quickly and so well! Thus modern painters, discharged from this preoccupation, proposed ways of seeing the world differently, through all imaginable means, with just one imperative: the rule of originality.
They formed schools, debated their ideas, the turbulent avant-gardists each treating the chief elements of painting in their own way – colour, form, object, matter, image. They upturned and overturned the tools and materials of painting. From the end of the 19th century, the Impressionists became fascinated with colour: they wanted to reconstitute, on their canvases, the actual effects created by light in the air and its reflection on the surface of objects. They also broke with classical perspective.

At the beginning of the 20th century, what was the role of colour? For Fauvism, it became a sign of freedom. More important still: colour acted as architect: organised in distinct planes, colour constructed a path and a space for the eye, without letting itself be imprisoned in the outlines of a design, a form. As for form, the Cubists and the Futurists would see to this: the Cubists, who circled around the objects they chose to show; then the Italian

19

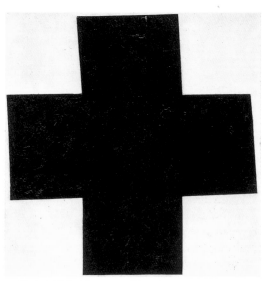

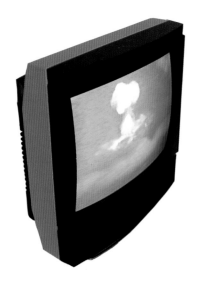

▲ **Kasimir Malevich** (1878–1935), *Black Cross against a White Background* (1915). Oil on canvas: 80 x 80 cm.

The artist reconstructs the world. He reinvents signs by means of geometry or rediscovers ancient symbols like, here, the cross.

▲
Image of a mushroom cloud on a television screen. Photograph.

The television screen is also a sort of modern window looking out at reality, at a complex and threatening world.

◀ **Joan Miró** (1893–1983), *Bleu II* (March 1961). Oil on canvas: 270 x 355 cm.

Space opens onto a dreamlike landscape, where the infinitely large and infinitely small meet.

Futurists, who sought to portray movement in a painting. Form lost its closed, solid character. It also sometimes lost its unity, to the point of shattering, and disappearing from the surface of the painting.

Meanwhile, other painters were organising form as a kind of architecture of geometrical figures. These were the abstract geometers, one of the principal of whom was Malevich.

Then the horrors of the First World War intervened to shake the optimism of these first avant-gardists. The Dada movement was born: the work of art itself was now re-examined. It was torn apart, and absolute negation and contradiction erected as forms of art. In a word, this was anti-art.

After Dada, painters continued to multiply their experiments. Painting was no longer a mere conduit towards some depth hidden behind it. It was a concrete surface, full and solid, an object in and of itself on which painters inscribed signs. For the Surrealists, the painting was a means by which the painter's unconscious could be expressed, revealing inner mysteries. After the Second World War, for the painters of the American avant-garde, and for certain informal European artists, the canvas became a kind of record of a certain moment in the life of the artist, of the time he or she spent painting it. The artists of the Pop Art movement chose banal, everyday images that they arranged on the surface of the painting: photos of stars, or supermarket products, became so many troubling symbols of an era.

Modern artists gained the following: they widened their scope, transformed their tools and products. The modern work of art is entirely devoted to making materials or movement palpable, to revealing a thought, or enhancing an emotion.

The modern work no longer addresses itself to all eternity. Its place is in the present, in a particular moment in the artist's life. Art and life have become simultaneous, intertwined experiences.

And today, despite the quantity and diversity of the images around us, painters continue to paint. Museums still display works of art, to a constantly expanding public. For more and more eyes are eager to explore the regions revealed by painting.

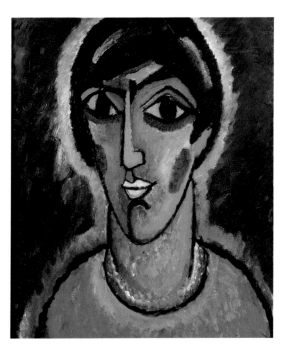

Sonia Delaunay ▶
(1885–1979),
*La Prose du
Transsibérien* (1913).
Oil on canvas:
193.5 x 18.5 cm.

Light, decomposed,
becomes rhythm.

◀ **Alexej Jawlensky**
(1864–1941),
Byzantine (1913).
Oil on cardboard:
64 x 53 cm.

Against the black
background, the
colours of the face
resonate.

Georges Braque
(1882–1963),
*The Little Bay of
La Ciotat* (1907).
Oil on canvas:
36 x 48 cm.

With a few casual
touches, a landscape
appears.
▼

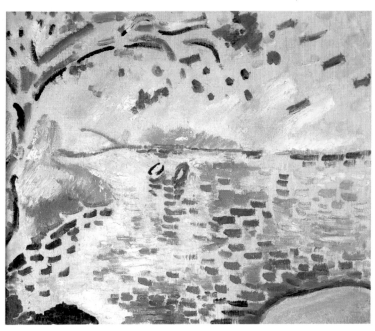

Colour, colour everywhere

Colour talks. Colour shouts. Colour speaks, sings, reassures. With seven basic shades (red, orange, yellow, green, blue, indigo, violet) which combine in endless nuances. "A black, E white, I red, O blue, U green...": correspondences imagined by Arthur Rimbaud, in his poem *Voyelles* ("Vowels"). For, on the subject of colour, each eye seems to have its own language, even if, for all, yellow is the closest to light, and blue to shadow. What is colour? For scholars, it's a vibration of light. Or rather, the sensation transmitted to the eye by this vibration, like the vibration of a sound to the ear. From Antiquity to modern-day optical science, scholars have sought to describe and measure colour.

They distinguish traits like luminosity, brilliance, tonality, saturation, where we would say light or dark, tint, purity, transparency or opacity. But physicians, painters, and poets alike, all must think seriously to be sure of what they are seeing.

Colour has its history. In the beginning, the painter, jealous of his secrets, crushed his own colours, using earth or other animal, mineral or vegetal matter. But since the end of the nineteenth century, colours are concocted industrially – a new kind of alchemy, sold in a tube. Colour also has its order. There are the colours of the gods and pagan colours, the colours of the rich and those of the poor. Colours of the day and those of the night, the colour of peace, the colour of fear. For the Chinese, white is the colour of mourning, whereas in the West, it is black...In the middle of the last century, the painter Delacroix noted in his *Journal:* "Colour is a powerful and mysterious force; it acts, one might almost say, unbeknownst to us." In the old debate which opposes, on the one hand, colour, and on the other, the line, the drawing, the brushstroke, Delacroix shows a preference for colour. Colour is in the surface, it covers, it invades. The line separates, cuts, and constructs. But can one

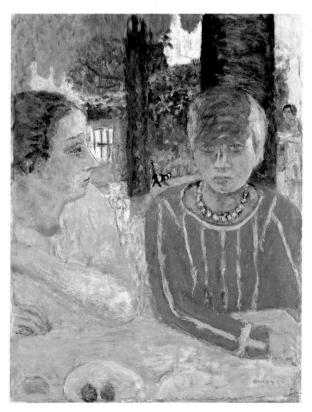

Pierre Bonnard
(1867–1947),
*Reine Natanson and
Marthe Bonnard
in a Red Blouse* (1928).
Oil on canvas:
73 x 57 cm.

The yellow of the
foreground and the
blues of the garden
direct our eye towards
the red garment
of Marthe, the
painter's wife.

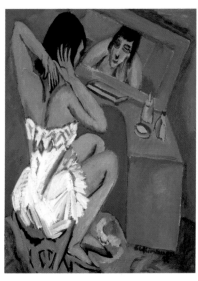

▲
**Ernst Ludwig
Kirchner**
(1880–1938),
*The Dressing Table
(Woman at Her
Mirror)* (1912–13).
Oil on canvas:
100 x 75.5 cm.

The vigour of
the brushstroke,
the violence of the
colours: Kirchner's
world is a raw,
tormented one,
as is often the case
with the German
Expressionists.

◀ **André Derain**
(1880–1954),
The Bridge of Chatou
(1904–05).
Oil on canvas:
81 x 100 cm.

In a cold, remote
grey-blue, the paved
street twists to
rejoin the vertical
of the canvas.

really disassociate the surface and the line? In the 1870s, the Impressionists dreamt of solving the mysteries of daylight, understanding the secret truth of reflection. The work of Monet, Pissarro, and Renoir used the experiments of scientists, such as those of the chemist Chevreul.

This collective reflection reinforced the experimental curiosity of scholars even as it added to the freedom of painters. Gauguin, Van Gogh, Cézanne showed a boldness that shocked more traditional artists, those who had studied in the Académies, those for whom "tradition" meant "learnt at school". For the new artists, who were opening the door to the 20th century, painting was no longer only a question of technique. What did they care that nature itself never appeared in pure, unadulterated colours but through an infinity of nuances?

The use of pure colour, direct from the tube, without shades or half-tones, is thus a modern-day liberty. Towards 1905, in France, a group of young artists exploited, without restraint, the emotional force of colour. It was the time of "coloured eccentricities": the Fauves, as they were nicknamed in reason of the virulence of their colour schemes, no longer sought to harmonise their palette with the nuances of nature, but rather to translate the effects produced on the observer. For colour acts! And the purer it is, the fuller and richer it is, the stronger the emotion...

The Northern painters also knew that colour has power. As early as the 1890s, in a break with convention, the Austrian Gustav Klimt, the Norwegian Edvard Munch, the Dutchman Van Gogh and the Belgian James Ensor were using the pure colours of modern times. In Russia – after 1917, the U.R.S.S. – popular art and religious painting had, for a long time, shown that colours speak to the soul. This was the spiritual dimension, underlined by Kandinsky, whose Slavic background led him to see art as a means of mystical elevation.

The techniques for making colours changed. Painters became more free in the way they used them. New rules were created, new harmonies invented, which the eye learned to recognise. Colour invaded the streets, walls, posters. Painters went on experimenting. In certain cases, when some experiments were taken to an extreme, colour could even become an end in itself, the actual subject of the painting. "Monochromatic", was the term used to describe works where colour, painting, and canvas merged into one.

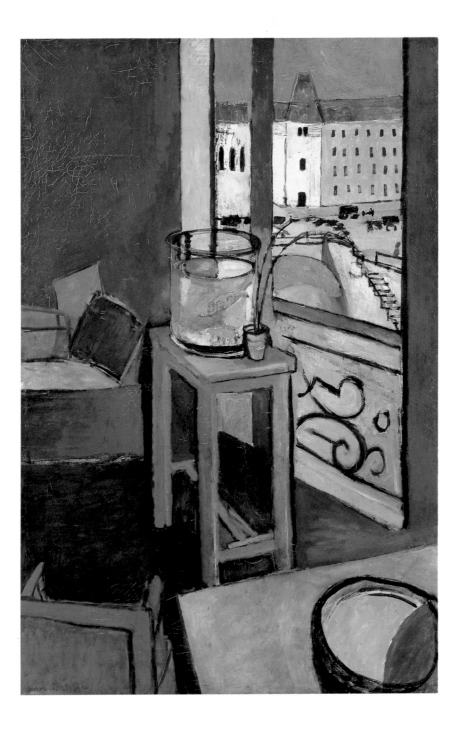

HENRI MATISSE
colour as architect

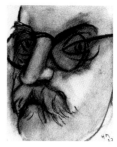

▲
Henry Matisse, drawn
by himself in 1937,
at the age of 68.
Charcoal on paper:
25.4 x 25.3 cm

In painting, colour is all-powerful. Matisse devoted his life and art to demonstrating this. His workshop was fashioned by colour, an intense blue which invaded every corner of it.

On a little table, a bowl of blue water sits in front of a window. In the background is a fragment of a Parisian landscape. Goldfish, suspended in their movement, float in the centre of the composition. All the elements appear to lean in towards the fish in a fragile balance, centred around their orange-red brilliance.

Space is a single continuum, from the horizon to the interior of my bedroom-workshop. Matisse.

a room with a view

Objects and furniture are deformed by an exaggeration of the vanishing point. The bottom of the painting tips perspective: in the foreground, our gaze is directed towards the armchair and the tabletop. In the background, the rest of the scene is taken in at eye level.
With our attention divided between the near and the far, between surface and depth, we are drawn into the room. The plant links interior to exterior, and the light-coloured vertical edge of the windowsill divides the vivid blue of the sky from the deep blue of the room's wall. The variation in the shades of blue separates the inside from the outside.
Is this vision not true to life? The painter doesn't care. All that counts is the pathway he constructs for the eye. The lines of the drawing lead our eye towards this opaque surface, which draws in our gaze more deeply than does the window's transparency. And it is this depth that Matisse is aiming for, as he works and reworks the colours.

Vanishing points and flat surface techniques
In a painting composed using classical perspective, the vanishing points guide the eye to the axes along which one can measure the distance between the objects, the space between the various planes of the painting. The opposite technique, painting applied with flat brushstrokes, produces the appearance of a full surface.

◄ **Henri Matisse**,
French painter
(1869–1954),
Interior with Goldfish
(1914).
Oil on canvas:
147 x 97 cm.

27

when Matisse created space with colours

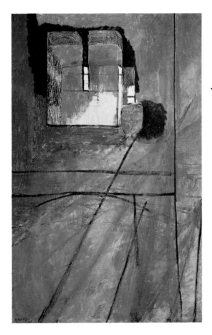

◄ **Matisse**
View of Notre-Dame
(1914).
Oil on canvas:
147.3 x 94.3 cm.
Museum of Modern
Art, New York.

Notre-Dame Cathedral
is an emptied-out
geometrical volume,
thrusting through the
blue curtain. The light
is diffuse, its source
not deriving from any
single point. The green
bouquet and its black
shadow cut through
space and make it
vibrate.

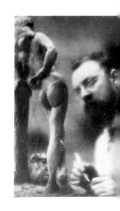

▲
Matisse in his studio,
c. 1905.
Photograph
by E Steichen.

Light
With his painter
friends Signac, Derain
and Marquet, Matisse
would study the sharp
contrast produced
by the strong light
of the Mediterranean
seaside. He had
returned from
Tangiers only a few
months earlier when
he painted *Interior
with Goldfish* and
View of Notre-Dame,
in his studio on the
Quai Saint-Michel,
in Paris.

At the beginning of the century, the Fauve painters created a scandal with the violence and boldness of their colours. But ever since, colour has no longer played the role simply of filling in the drawing's space and perspective. It is no longer enclosed in the brushstroke which defines it, but has acquired independence. It now serves another purpose than just that of imitating, reproducing the colour of things as we perceive them, what painters call "local tones". As in Oriental painting, modern painters use the different degrees of intensities of colour to convey depth on the flat surface of the canvas.

surface and depth

Thus, instead of creating volumes by playing on the relation between form and shadow, Matisse organised space using surfaces painted with flat brushstrokes, but of varying intensity and brightness. He sought, in his words, "a harmony of all the flat colours", a balance between the path of the line and the coloured surface.

*I did some sculpture
so as to order my
sensations, to seek a
method. Once I had
found this in sculpture,
it was useful to me
in painting.*
Matisse.

Windows
The window is a theme which has fascinated artists for centuries. The equivalent of a painting within the painting itself, it facilitates communication between worlds, an entrance into other dimensions. Matisse uses windows frequently, thus creating complex visual spaces.

Throughout his life, Matisse's preoccupation was to integrate form and colour. He wanted to find the point of correspondence between what colour alone can express, on the one hand, and on the other, the ordering of forms, the painting's composition.

By 1910, Matisse had acquired a degree of fame, which enabled him to work with a maximum of artistic freedom. Even as he studied colour, he also sought to perfect his mastery of form through fluid and spontaneous drawing. The harmony among drawing, subject and colour allowed him to attain a simplicity of means, that apparent ease with which he seems to have painted his works.

In the floral compositions and the portraits of women which came to dominate his work, Matisse continued to seek a sensual balance, celebrating voluptuous pleasures and the delights of the eye.

When I use green, it does not necessarily mean grass, when I use blue, it does not mean the sky.
Matisse.

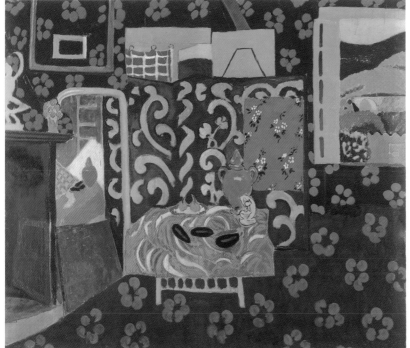

◀ **Matisse**
Interior with Eggplant (1911).
Tempera with animal glue on linen canvas: 210 x 244 cm.
Museum of Fine Arts, Grenoble.

A singularly lively still-life, rhymed by arabesques and by floral and plant-like motifs covering the coloured surfaces.

gouaches on paper, or how to cut in colour

Coloured drawings
Paper cut-outs,
noted the painter,
represented "coloured
drawings without
pretension, whose
only aim is to use fine,
ready-made colours,
without disturbing
their purity. What
intoxication, just
to open a package
containing a kilo
of blue, a package
of yellow, of green, or
ochre red, or brown,
or even of black..."

N either age nor illness kept Matisse from working with vigour. When he was already over 70, giving instructions to his assistant from his bed, he developed his method of "gouache cut-outs". These gouaches on paper were a solution to the traditional conflict of line and colour: "Instead of drawing the shape and installing colour within it, I draw directly in colour." With a single gesture, he discovered that one can associate line and colour, shape and surface.

sculptured colour

To present his work of cut-out gouaches, Matisse imagined an album that he called *Jazz* – which he wanted to make, in the domain of painting, as rich in rhythm and improvisation as the music of the same name.
He expanded to a large format the technique of cut-out papers, using it to compose large-scale paintings like *The Sorrow of the King* or to design stained-glass windows and decorate the chapel of Vence, in the south of France, in 1949. To better pursue his exploration of colour, Matisse even tried his hand at architecture.

▲
Matisse
Yellow and Blue Interior (1946).
Oil on canvas:
116 x 81 cm.

Decorative objects
are caught between
blue planes.
Repetitive motifs
animate the flat
surface colours.

Matisse left as a legacy neither a school
movement. His importance was much mo.
general. In the eyes of many of today's pa.
personified the traits of fine quality and clairvoy.
the artist's work. "In the end, there is only Matisse
Picasso said. His bold yet carefully thought-out expe.
iments made him a rare wise man among the moderns.
His discoveries contributed to nourishing numerous
contemporary tendencies: his paintings have been
viewed as he himself viewed those of Cézanne. This
innovator opened up a path between colour and line.

even in America

In the 1950s and 1960s, certain American painters
would claim to be spiritual heirs of Matisse. Sam
Francis, for example, or Mark Rothko who, in 1954,
the year of Matisse's death, entitled one of his paintings
Homage to Matisse. Even if they chose the road of
abstraction, these painters recognised Matisse as a
master, and remained faithful to his sensitivity to pure
colour, which they in turn made vibrate on canvases of
often imposing formats.

Sam Francis
(1923–94),
In Lovely Blueness
(1955–57).
Oil on canvas:
300 x 700 cm.

With Monet and
Matisse in mind,
the American painter
uses colour on a large
scale. Three meters
high, seven meters
long, a pond, blue
with the reflection
of the sky.
▼

31

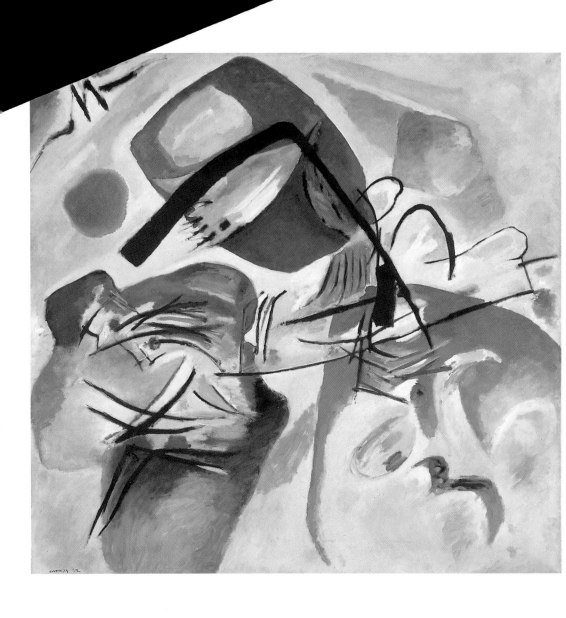

KANDINSKY
inner colour

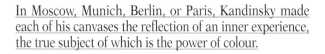

In Moscow, Munich, Berlin, or Paris, Kandinsky made each of his canvases the reflection of an inner experience, the true subject of which is the power of colour.

From a grey mist which fills the almost square surface of the canvas emerge three masses of colour, more or less vivid, like three continents. The first floats at the top, a vague darkish-red cube. Below it is a blue volume, enclosed upon itself, somewhat formless, appearing almost translucid in places. It is clawed at by black lines. To the right, the edges of a red triangle extend beyond the frame.

a suspended world

Around these three central figures, a strident red spot creates a luminous sun; a small ochre volume with irregular facets pierces through the grey mist against an emerald background; a black sign scratches an angle of the painting. Each element seems suspended, weightless, without top or bottom, without any scale of measure.

One form dominates, however, dominates and connects the great unities of the painting: the black arc. This is what marks the pyramidal architecture of the composition. It imposes a fragile equilibrium on a world where nothing seems natural. There is not a trace of perspective. A few black lines, filaments or half-traced letters, punctuate the canvas. Only the vibrations of the colours, applied with little, very visible brushstrokes, animate the surface of the painting. And yet one feels a vague unease, a discreet threat: here, as in all his work, Kandinsky "speaks to the soul" of the observer.

◄ **Wassily Kandinsky,**
a painter of Russian origin, naturalized German, then French (1866–1944),
With the Black Arc (1912).
Oil on canvas:
1.89 m high,
1.98 m wide.

Driven from one end of Europe to the other
Born in Russia, Kandinsky, at age 30, moved to Germany. In 1914, when the war broke out, he returned to Moscow. He remained there until three years after the Bolshevik Revolution of 1917, then came back to Germany to teach. In 1933, when the Nazis rose to power, he took refuge in France, where he lived for almost ten years. Criss-crossing Europe in this way helped him introduce his lucid and impassioned aesthetic ideals to a wider public.

33

Kandinsky sought the spiritual in art

Kandinsky felt that painting should nourish the soul, not just the eyes. Composing a painting thus no longer meant only representing what the artist saw around him. It meant organising forms and nuances to create feeling.

Kandinsky studied the power of colours, sought to rediscover the emotions that Russian folk art had inspired in him. He gave classes, wrote books in which he explained the principles that he applied in his painting.

For instance, white and light colours are associated with birth and life. Conversely, black, darkness, shadow evoke suffering, mark the passage towards death. Yellow is a warm colour, physical, so luminous that it always seems to be unfolding, expanding. Blue, on the contrary, is cold, cerebral. It appears to contract, to sink. Red, a vital colour, is the opposite of green, unmoving and passive.

Indefatigably, Kandinsky explored forms, colours and rhythms. He didn't choose his tones simply because they existed in nature but rather, he explained, because,

In 1912, Kandinsky published *Klange*, a collection of poems which translated into words the sense of his painting: "Inside, a blue cloud hovers. The red cloth is torn. Red strips, blue waves."

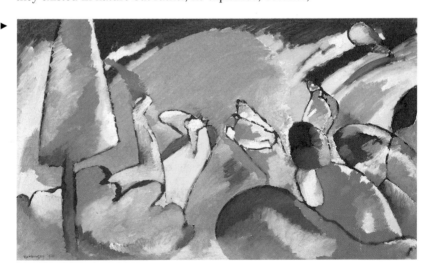

Kandinsky ►
Improvisation XIV (1910).
Oil on canvas: 74 x 125.5 cm.

The forms are scarcely identifiable here: two knights face each other, on two lavishly fitted-out horses, but who can recognise them?

Kandinsky ▶
In the Circle (1911).
Watercolour, gouache,
and Indian ink on brown
paper: 48.9 x 48.5 cm.

Inside the circle formed
by the brown hatchings,
vibrant signs criss-cross
the canvas, a whirlwind
of calligraphic traces
and shapes.

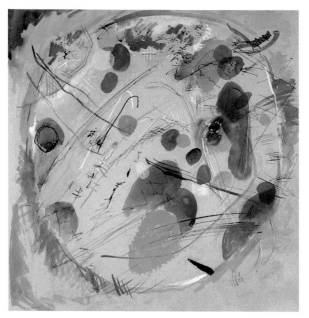

Colours and sounds
Kandinsky developed
a parallel between
colour and music,
shade and sound.
Yellow is piercing,
blue evokes the sound
of a flute when it is
light, then, as it gets
darker, the sound of
a cello and a bass.
A musician himself,
he painted sets and
costumes for music by
Moussorgsky. Like his
friend the composer
Arnold Schönberg,
he was more interested
in dissonance than
in classical harmony.

*Art is the only language
which speaks to the
soul, and the only
language the soul can
understand. It finds in
art, the only form it
can truly assimilate,
its daily bread, which
it dearly needs.*
Kandinsky.

with such or such a specific resonance, they were "essential to the painting".

Kandinsky discovered this principle of "inner necessity" by chance one day in 1908, when he saw one of his paintings hung upside down and still "shining with an inner light". Overcome with emotion, he understood that there was no need to represent objects. Using painting alone, its colour, its matter, he discovered the possibility of communicating in a "pure language which speaks to the soul".

Freed from the obligation of representing the world, the painting expressed a sensation, an emotion. Whether in his writing or on his canvases, Kandinsky thus expressed an idea which would come to be known as "abstraction": the painting of forms independently of reality, forms which need resemble nothing other than themselves, which imitate nothing, but provoke an unexpected reaction or emotion whenever they appear.

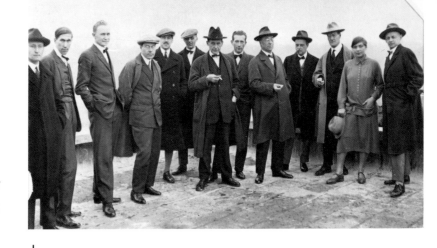

the modern school, or a new tradition: abstraction

▲
The Bauhaus professors in 1925. Photograph. Kandinsky is fifth, and Paul Klee fourth, from the right.

In 1919, an exceptional art school opened in Germany. It was the Bauhaus, the "house of construction". There the architecture, as well as the industrial design, furniture, and graphic art of the future were invented. From all over Europe, artists with the most modern ideas brought their experiences of form, of colour, of techniques and of materials to the school.

Kandinsky taught at the Bauhaus for ten years, and there had the opportunity to formulate and make known his theories on abstraction. In 1933, however,

◀ **Kandinsky**
Yellow-Red-Blue
(1925).
Oil on canvas:
128 x 201.5 cm.

From left to right, from the yellow in the foreground to the blue which gives depth, the painting proposes a progression from the rectangle to the circle, passing through reds in intermediate forms. One can read in it an allegory of the senses: the yellow eye projects the observer's gaze forward, the blue ear absorbs the sounds.

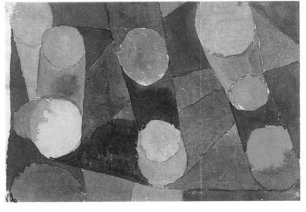

Paul Klee ▶
(1879–1940),
*Abstract, Coloured
Circles Connected
by Ribbons of Colour*
(1914).
Watercolour on
cardboard:
11.7 x 17.2 cm.
Kunstmuseum, Bern.

Like rays of luminous
projectors, the coloured
circles create a rhythm
that the eye then
extends beyond
the surface of the
modest-sized painting.

Degenerate art
This was the Nazis'
term for modern art,
which they sought
to eliminate, as they
would later eliminate
men. In 1937, they
organised a travelling
exhibition with
this title.

the Nazi regime forced the school to close its doors. No individual artist "invented" abstract art. Many, rather, came to it gradually by different paths, until abstraction became a decisive characteristic of modern painting, a discovery. It freed the eye, made it sensitive to a new aesthetic ideal, distinct from the forms of simple decoration. By following, whether he wanted to or not, the transformations that these artists brought about in painting, the observer, and his expectations, naturally adapted since, decidedly, "art doesn't reproduce the visible, it makes things visible." (Klee).

*Colour and I are one.
I am a painter!*
Paul Klee.

**Avant-garde friends
together**
Another professor at
the Bauhaus, Paul
Klee, developed his
own areas of
experimentation, all
the while dialoguing
with Kandinsky. His
art is a systematic
study of colour and
signs, parallel to that
of Kandinsky.

Kandinsky in his ▶
workshop with
Paul Klee, in 1926.
Photograph.
Kandinsky's workshop
was temporarily set
up in the municipal
Kunsthalle (art school)
of Dessau. *With the
Black Arc* is leaning
against the back wall,
along with other
paintings.

YVES KLEIN
colour alone

Yves the Monochromatic (as he nicknamed himself) pushed the experience of pure colour to one of its extremes. Beyond provocation, his painting is charged with power and energy.

Just for a moment, the eye hesitates, seeks a clue, a hidden sign. But nothing appears: the painting is only that, then, a rectangle of intense blue. Is there thus nothing to see? The impatient observer will continue along his path, disappointed by the absence of the slightest sign or image. But he who stands for a moment before the canvas will soon notice that this blue reserves some surprises.

Klein ▶
*Green Monochrome
(M77)* (1957).
Pure pigment,
synthetic binder and
coating on a canvas,
mounted on wood:
105.3 x 26.8 x 4.7 cm.

◀ **Yves Klein**,
French painter
(1928–62),
*Blue Monochrome
(IKB 3)*.
(1960).
Pure pigment and
synthetic resin on
canvas, mounted
on wood:
1.99 m high,
1.53 m wide,
2.5 cm thick.

all you see is blue

At first sight, the painting appears to be a simple surface, entirely filled with colour. It does not blend into the wall, but detaches itself from it, as the painter wished.
The ultramarine blue is so saturated that it soon tires the eye. A coloured vibration radiates out from this bluer-than-blue and attains maximum amplitude. Then the uniformity starts to come to life. The surface appears a bit fluffy: this is the trace of the roller that the artist, for the occasion, borrowed from a house painter. The colour's pigment takes on the consistency of a rough cotton canvas. Each passage of the roller has left light stripes, which design strange landscapes with a floating horizon. The observer's gaze plunges into a depth which does not belong to the three-dimensional space of daily life, but to an additional dimension that the painter invites us to explore: the depth of colour.

life in blue, Yves Klein style

◄ Photograph of several *Blue Monochromes* exhibited at the MNAM in 1983.

They represent so many windows open onto the abstract dimension of blue, onto worlds specific to each painting.

Patented blue

On 19 May 1960, Yves Klein took out a patent for the formula of his blue, under the name of International Klein Blue (IKB). In fact, it is fairly easy to imitate and reproduce IKB. When he took out the patent, Klein wanted to obtain acknowledgement of the fact that his colour was not just any blue, among others, but precisely this blue. He was not so much interested in protecting his property as in underlining the unique character of a painter's choice.

⊤his outsized blue not only draws the observer's eye: the mind sees along with the eyes. With the "monochrome", the impact of colour remains total. Colour is a concrete given, but it also has a powerful and immediate effect on the viewer's psychology.

In his paintings, Yves Klein is as interested in the spiritual as the physical. For him, painting is an affair of meditation, an "intangible" process. It is outside of daily life, opening a path towards reflection.

By playing on simplification, Klein acquired a reputation as a *provocateur*. As the technical aspects of his art are

Blue has no dimension, it is outside of dimensions, while the other colours have them. All the colours lead to concrete associations of ideas, while blue reminds one at most of the sea or the sky, which are, after all, among the most abstract entities in all of tangible and visible nature.
Klein.

Klein ►
Monogold, MG 18 (1961).
Pigment, synthetic resin and gold leaf on a canvas mounted on wood: 78. 5 x 55.5 cm. Ludwig Museum, Cologne.

Gold is both a colour and a value. Patches of blue are perceptible through the fine surface of gold leaf covering the blue background.

Klein ►
Anthropometry of the Blue Period (ANT 82) (1960).
Pure pigment and synthetic resin on paper, glued to the canvas: 155 x 281 cm.

With these prints on paper, the painting reminds us that a living human being has come this way.

Klein organised public painting sessions in the form of solemn ceremonies. Thus, one evening in 1960, he guided "woman-paintbrushes" over the canvas while musicians played the *Symphonie monoton*: 20 minutes of one sustained chord, followed by 20 minutes of silence.

reduced to a minimum, the observer is not placed before a demonstration of the painter's virtuosity but simply subjected to the pure effects of colour. "Anyone can do that", is a common reaction to a monochrome.

However, this is to forget that achieving simplicity requires true effort. One must go through a careful process of systematic experimentation to reduce or eliminate any trace of the process of painting, so as not to disrupt the stretch of blue.

With the *Anthropometries*, Yves Klein made use of another elementary principle of painting: like children who paint with their fingers, he painted with bodies. He coated the model's body with paint, and applied it to the surface of the paper. The painting then became the record of an event, registering a moment in life.

Klein made painting a means of expressing the energy of being alive, that energy that he expended limitlessly for each of his projects.

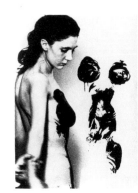

▲
A woman-paintbrush and her prints.
Photograph, 1960.

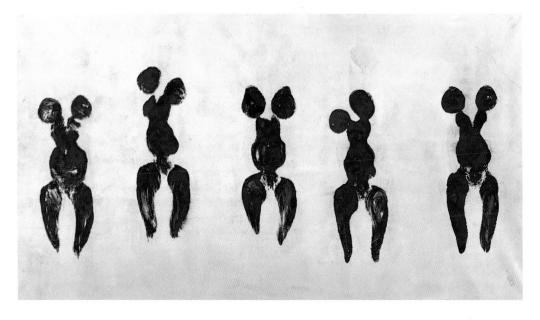

41

the mono-chrome, or an alchemy of colour

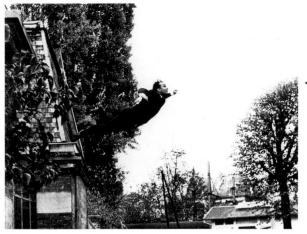

With Yves Klein, the painter became a multi-faceted personality, and the search for novelty was a mystical adventure. Judo, which he practised at a very advanced level, is after all, both a physical and a spiritual pursuit. He discovered Zen philosophy, Rosicrucian mysticism, and later became a Knight of the Order of San Sebastian. This taste for the adventures of the mind, religious ceremonies and rituals is symbolic: for Klein, the artist played a sacred role in society. To open up new avenues of reflection, he dramatised his own character, publicised his doings. Thus he took on the role of editor-in-chief of a one-day-only newspaper whose chief subject was...Yves Klein!

gold, fire, nothingness

Provocation and scandal: in 1958, over two thousand people crowded into a gallery opening – but the gallery was empty! Or rather, said Yves the Monochromatic, it was filled with "the idea of a pictorial sensibility". The exhibition was indeed called *Le Vide* ("Nothingness"). The quest for immateriality was becoming a vast practical joke. Soon, Yves Klein was painting with a fire-thrower, flinging gold nuggets into the Seine, lighting up in blue the obelisk of the Place de la Concorde.

◀ **Klein**
Blue Tree (SE7l)
(1962).
Pure pigment and
synthetic resin on
sponge and plaster:
150 x 90 x 42 cm.

Sponges were used to
transmit colour onto
the paintings without
leaving marks. But,
struck by the beauty
of the blue on the
sponge, Klein made
the tool itself into
a work of art.

As early as the 1920s, Russian avant-garde artists had thought of monochromy. But it wasn't until the 1960s that the technique came into its own, with Klein in France, Fontana in Italy, and, in the United States, Robert Ryman who painted only white canvases.

Of all the simplifications that painters have invented, monochromatic painting is one of the most striking, implying as it does the dream of pure, absolute painting, without image or form. It is both concrete, because the painting is an object produced with almost mechanical means, and abstract, because colour leads the observer towards the most direct and immediate sensations.

An indispensable visual contact
Probably more than any other, monochromatic painting loses a great deal of its energy when reproduced. In a print, the monochromatic painting becomes a smooth surface, flat and lifeless. Whereas in a museum, before the painting itself, the eye can appreciate, to an almost dizzying degree, the subtle variations of colour.

Lucio Fontana ▶
(1899–1968),
Spacial Slit Concept
(1958).
Vinyl painting on canvas: 125 x 100 cm.

Lucio Fontana crossed, by chance, a new frontier in his work, in an angry gesture directed against a painting that he couldn't manage to finish. This is how he discovered, he recounts, the "laceration" movement. The slit made by the cutter becomes a strong message, a sacrilegious wound threatening the act of painting itself.

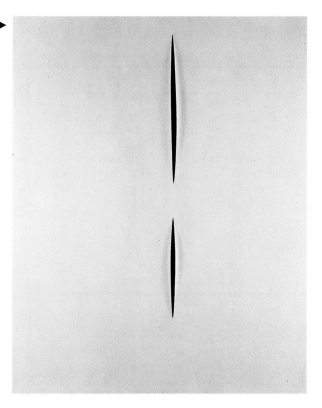

Monochromy is the only kind of painting which allows one to attain an absolute, spiritually speaking. Klein.

43

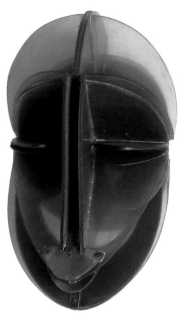

Antoine Pevsner
(1886–1962),
Mask (1923).
Celluloid and metal:
33 x 20 x 20 cm.

Form, emptied out,
creates volume, and
is reminiscent of a
stylisation common
in African art. Pevsner
chose a synthetic,
modern material,
celluloid, to form this
face which is half-
human, half-machine.

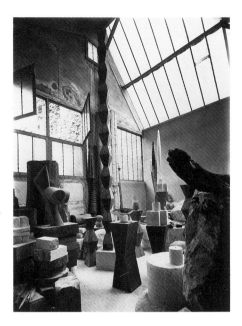

▲
Constantin Brancusi
(1876–1957),
*General view of the
workshop* (c. 1925).
Photograph by
the artist.

An *Endless Column*
in the background, a
version in plaster and
another in polished
bronze of the *Bird
in Space*, and, on
the right-hand side,
the *Cock*. The forms
are immaterial, as
abstract as the trace
of a bird's flight.

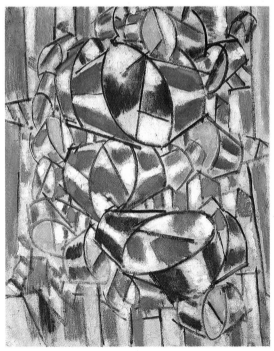

Fernand Léger ▶
(1881–1955),
Contrast of Forms
(1913).
Oil on canvas:
100 x 81cm.

In the tradition
of Cézanne, Léger
constructs geometrical
volumes, cones, drums
hatched by white and
coloured bands defined
by black markings.

The new outlines
of form

Everything has a form, though it may be unstable, changeable, or temporary, bestowed by nature or fashioned by man. Form is one of the aspects of the objects that we see, the shape of the volume, the appearance they present in the light. Form allows us to recognise things, to note similarities between two shapes.

The forms of nature were thought for a long time to have been determined by God. Here, the forms under discussion are those proposed by artists alone, those gods of the visual arts.

Creating a work of art, building, sculpting, drawing, composing a tragedy or a symphony always means imposing form on given materials.

Forms, in art, are the result of a voluntary activity, a creation. They are determined by the constraints of the craft, the rules of technical production. But they are also a function of the imagination: that is, of the manner in which each individual is capable – if not of inventing them – in any case, of accepting or recognising them.

Each period has its forms, its style. Each domain, like industry or architecture, invents its own, which must answer to precise needs. Art transforms old ones or brings forth new ones, without conforming only to the rules of utility or functionality.

Painters and sculptors help to create and make acceptable new shapes for objects, to make certain lines, traits, curves and rhythms pleasant to look at. It is a matter of drawing, or of volumes.

In painting, in sculpture, faithfulness to the real world of daily life, respect for visual resemblance, are traditions of Western culture. If modern art sometimes shocks, if it remains an enigma for many, this is because it is determined to effectuate a break with these traditions.

Representing what he sees is no longer the chief concern of the painter.

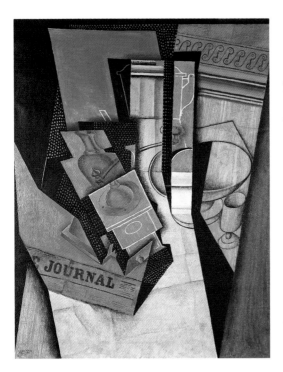

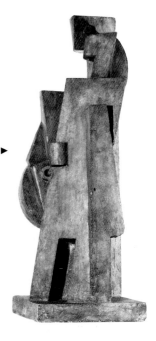

Jacques Lipchitz ▶
(1891–1973),
*The Man with
the Mandolin*
(1917).
Polished plaster:
81 x 30 x 30 cm.

A right angle traces
the nose, the eye is a
little hollow cylinder.
Lipchitz's man is a
symbol rather than
a representation
of the real.

▲
Juan Gris
(1887–1927)
Breakfast (1915).
Oil and charcoal
on canvas:
92 x 73 cm.

The painting gives form
to the world, unconcerned
with reproducing visible
forms in their totality.
The painter cuts and
reconstructs reality
according to his own rules.
He gives us a puzzle, each
part of which corresponds
to a different moment
of the act of seeing.

Michel Larionov ▶
(1881–1964),
*A Stroll: The Venus
of the Boulevard*
(1912–13).
Oil on canvas:
116 x 86 cm.

Full and ample form,
caught in movement,
is broken down into
many facets: one, two,
three, four feet compose
a step, amidst an
explosion of colour.

Since the photographer now plays this role, the painter can take the risk of painting with no subject. His task is now, on the contrary, to show what neither eye nor lens can perceive, to create forms with no direct equivalent in nature.

Henceforth, form can impose itself even without a model. As early as 1910, form began to lose its continuity, its immobility, its static character. With the Cubists' paintings, objects decomposed when the painter's point of view shifted. With the Futurists, the object was portrayed in motion. What form lost in unity, it gained in energy. Are not speed and motion major preoccupations of our century?

With industry and design, form learned how to be functional, when conceived in relation to a need to be fulfilled. In art also, form could be rational, inspired by a deliberate strategy, or reasoning. For it was now a question of bringing forth things that had never before been formulated, but no longer was it necessary to give a recognisable image of them. Geometry – the science of space – was there for that. As techniques and materials changed, our gaze, in turn, was developing, and our visual imagination being transformed, in search of forms suited to the changing world.

If the autonomous form is an invention characteristic of this century, it neither replaced nor did away with the habitual, traditional given forms. Alongside the images produced by the camera's lens, mimetic forms, faithful to outside appearances, had not yet had their last word.

But meanwhile, a new tendency began to grow: that of letting form create itself, independently of all preconceived models. This was the reign of the informal: raw, direct form, which appeared at the point where gesture met material. It implied a rejection of calculated, sophisticated form, diametrically opposed to geometrical mastery. Wild, vibrant form as opposed to domesticated, mastered form...

By throwing off, transgressing the limitations imposed by history, painting and sculpture produced a new way of looking at things. The world of form opened itself to all possibilities. But for the artist, the only thing that really counted was the form necessary for his work.

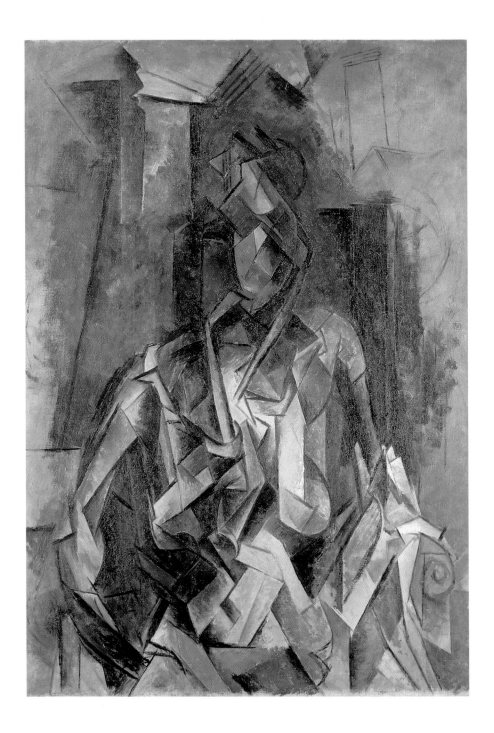

PABLO PICASSO
form exploded

Painter of the blue period, then the rose period, Neoclassical, then close to Surrealism, Picasso and his work were at the heart of the myriad transformations of the century. As early as 1907, along with Georges Braque, he paved the way to the Cubist revolution.

I wanted to paint things as one thinks them, not as one sees them.
Picasso.

In the background, against a mist-coloured canvas, simplified forms evoke a rudimentary landscape. In the centre, an imposing figure is seated in an armchair. The shoulders are profiled against the back of the chair, as is the head. Only the outlines of the body make it possible to recognise a human form. The face is reduced to an oval mask, composed of greyish and rust-coloured facets. A complicated coiffure rises above the head, culminating in a single point – a braid? – then falling back down to meet the body.

a volume composed of volumes

The entire body is constructed of the accumulation of geometrical fragments: in apparent disorder, small volumes overlap and intersect each other down to the bottom of the frame, making the mass of the body emerge. The light, which seems to come from the inside, accentuates certain facets and leaves others in shadow. This body is as solid as a sculpture, with a twisting movement of the torso: the right arm, a light rust colour, comes forward while the left shoulder, in grey, fades into the background. As in many paintings of the Cubist period, Picasso voluntarily limited his palette to greys and browns. He left aside, for the moment, the effects of colour: the construction of form was more important to him.

A modern genius
Pablo Picasso was the incarnation of the modern genius. His creativity, his productivity, the abundance of his inspiration, his political commitment, his private life intertwined with his art, made him a myth in his own lifetime.

◀ **Picasso**,
of Spanish origin, painter, sculptor, ceramic artist and engraver (1881–1973). *Woman Seated in an Armchair* (1910). Oil on canvas: 100 cm high, 73 cm wide.

Picasso shattered the world of form into pieces

The form of a body decomposed into fragments may seem far removed from the curves of a living body. With this elaboration of volumes composed of geometrical facets, Picasso constructs an architecture rather than an anatomy. This is because Cubism wanted to approach, as closely as it could, the hidden truth of objects, by seeking their actual form, their structure, rather than contenting itself with their outer appearance.

A taste for primitive art
Primitivism was the term given to the taste, or curiosity, shared by a number of modern artists, for the arts of Africa and of Oceania, and Eskimo art. The arts labelled "primitive" demonstrate a great expressive force through often very simple means.

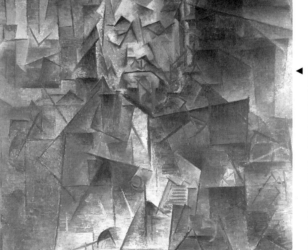

◀ **Picasso**
Portrait of Ambroise Vollard (1909–10). Oil on canvas: 93 x 66 cm. Pushkin Museum, Moscow.

The model's face has shattered into multiple facets, opaque or transparent. The shards of form, dispersed all over the canvas, occupy the entire surface of the painting.

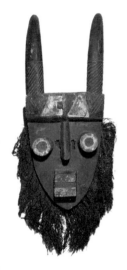

▲
Grebo Mask
From the Ivory Coast or Liberia. Painted wood and vegetal fibres. Height: 64 cm. Picasso Museum, Paris, Picasso's private collection.

50

On the art scene, Ambroise Vollard and Daniel-Henry Kahnweiler became the pioneers of a new role: that of art dealer. They put artists under contract, supported them, promoted and publicised them to a sceptical, sometimes sarcastic public. From 1895 on, Vollard was Cézanne's dealer, then Picasso's and Matisse's. And, from 1907, Kahnweiler looked after the interests of Picasso, Braque, Léger and Gris.

Picasso, in 1908, in his studio of the Bateau-Lavoir. Photograph.
▼

Picasso does not present on the canvas a representation of the object he sees. He proposes an equivalent of it, composed of signs constructed by the mind rather than perceived by the eye. Thus, with Cubism, the painter's perception changes. Instead of being interested only in the visual aspect of a subject, he dwells on his idea of the subject, the way his mind conceives of it. According to the poet Guillaume Apollinaire, one of the most fervent champions of the Cubist revolution, it is the difference between something *seen* and something *known*, or *experienced*.

like the pieces of a puzzle...

The facets represent so many distinct instants, different points of view, combined on the canvas in a calculated disorder. The unique, fixed vision imposed by traditional rules of perspective is abandoned: the painting unites different moments and aspects of the painter's perception of an object, a body.
A new construction, a new reading of forms now operates, beginning with these fragmentary structures. Volumes are suggested by angles, by edges, but also by letters, bits of objects referring directly to reality. Colours underline the dynamic effects of the forms, and give the painting depth.

... that the eye puts together

This exploded form, these superimposed planes construct an imaginary space. The observer can let himself be led from facet to angle; from outline to surface, and can construct in a new manner the illusion of volume.
Like the Fauve painters, Picasso was very interested in exotic arts, in sculptured forms from other cultures. Their geometrical stylisation, their decorative energy, helped inspire him to invent the forms of Cubism.

▲
Picasso
Woman's Head (1954).

Model for a monument erected in Flaine in 1991. Painting in three dimensions, or painted sculpture... Picasso spent his time as an artist inventing new relations between surface and volume, between two and three dimensions.

51

the collage, or when daily life invades the painting

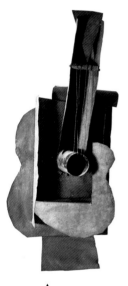

Picasso
Guitar (1912–13).
Sheet metal and wire:
77.5 x 35 x 19.3 cm.
Museum of Modern
Art, New York.

With collage and
later assemblage,
the distance between
painting and sculpture
was reduced.

52

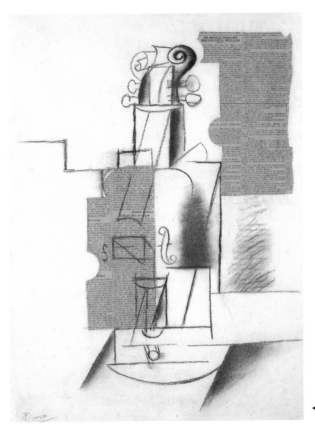

▲
Picasso photographed
in his workshop,
around 1911. He was
30 years old at the
time, and beginning
to become known
in Paris.

◀ **Picasso**
Violin (1914).
Charcoal and glued
paper: 62 x 47 cm.

Charcoal drawing
and play on shadows
contrast with the
flat surfaces of
the newspaper,
complementary
and inverse halves
of the composition.

Soon, Picasso began to integrate bits of daily reality into the painting. A simple studio exercise originally, the collage made it possible, in a single gesture, to include form and colour in the composition. Form was no longer just drawn, but cut out. The colour was that of a yellowed newspaper, or various motifs: *trompe-l'œil* imitation wood, wallpaper, letters and printed characters. With collage, the relationship of the painting to the real world was transformed. The painting no longer reproduced the world but displayed it directly, borrowing fragments from it. This technique soon became one of the century's most characteristic means of expression in the visual arts.

Cubism, one of the first avant-garde movements of our times, grew out of the meeting of two young painters: Picasso and Braque. They were just twenty-six. Picasso was impulsive, Braque reasoned more. Still, around 1908, both were reflecting on the same artistic questions: planes, volume, form, colour... In sum, they were rediscovering Cézanne's motto: "Treating nature through the use of the cylinder, the sphere, the cone..." Braque and Picasso discussed their ideas with each other. Together, they dared to go further than they would have alone.

Reassured by the support of their dealer, Kahnweiler, they multiplied their experiments. They would later say that during this period, the two of them worked like linked mountain-climbers, tied to each other with a thick rope of solidarity, braving risks together.

▲
Braque photographed by Picasso, 1908–10. With Braque, analysis often took precedence over creative fervour.

Paper and dust
Picasso wrote to Braque, in 1912: "I'm using your latest paper-and-dust-methods. I'm in the midst of imagining a guitar, and am putting a little dust on our horrible canvas."

The fact that Cubism remained misunderstood for a long time, and that still today there are people who remain baffled by it, does not negate its value. The fact that I don't read German, that a book in German is nothing more to me than black signs on white paper, does not mean that the German language does not exist, and I would never dream of blaming the author, but only myself.
Picasso.

Georges Braque ▶
(1882–1963),
Woman with Guitar (1912).
Oil on canvas:
130 x 74 cm.

The pyramidal scaffolding of facets suggests a woman's body, identifiable by the mouth. The guitar's form, a linear arabesque, is disjointed from its materials, indicated by the trapezoid in imitation wood.

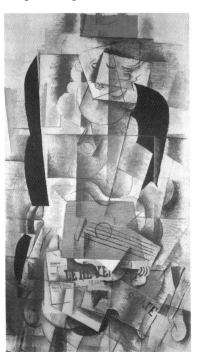

At the Chambre des Députés, on 3 December 1912, the Deputy M. Breton: I ask Monsieur the Undersecretary of State what measures he plans to take to avoid a repetition of the artistic scandal of the last Salon d'automne!
M. Sembat: One must think of the future when viewing artistic endeavours...
The deputy: You cannot call what the Cubists do artistic endeavours!
M. Sembat: ...When a painting seems bad to you, you have the indisputable right not to look at it, to move on to something else; but there is no need to call in the police!

53

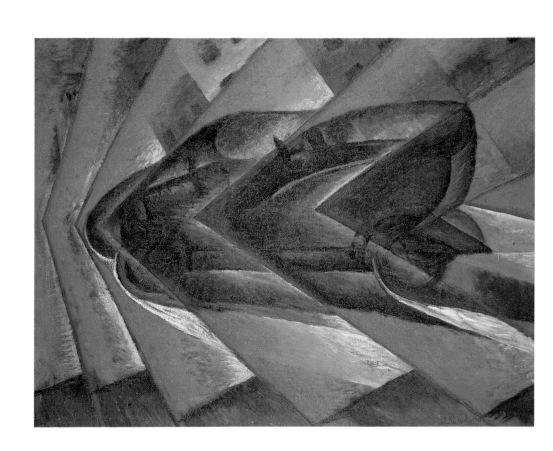

LUIGI RUSSOLO

form in motion

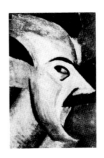

Painter and musician, Luigi Russolo was one of the significant figures of Futurism, that turbulent avant-garde movement which celebrated speed and the machine, in reaction to old and entrenched Italian artistic traditions.

So where is it, the automobile promised in the painting's title? What has the painter done with it? It is hardly recognisable, having disappeared in the expression of its own movement. Its blue silhouette, outlined against a coloured background, is decomposed in a succession of moments, of triangles locked into each other, whose angles open wider and wider in an effect of acceleration. From right to left, along a horizontal axis, a vibration of speed fills the painting.

the turbulence of coloured waves

The superimposed shells, blue towards the centre, red towards the edges, indicate the axis of movement. Absorbed in the whirlwind, the road disappears. The buildings in yellow and blue which suggest a city setting seem to sway towards the left of the picture. The entire surface of the canvas, in a fusion of colours and an explosion of shapes, speaks of motion.

In exalting the machine, Russolo sought to translate the sensation of speed, as he perceived it. But the geometrical rigidity of the composition comes to a standstill at the left-hand edge of the painting. The Futurist's dilemma is summed up in the following contradiction: that of making palpable an ephemeral sensation of motion, on the static surface of a canvas.

A lightning career
Though one of the five important painters of the Futurist movement, Luigi Russolo had a short career. A self-taught man, he painted for only four or five years, from 1909 to 1913, after which he dedicated himself to music.

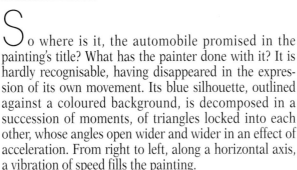

◀ **Luigi Russolo,**
Italian painter
(1885–1947),
*The Power of an
Automobile* (1912–13).
Oil on canvas:
1.06 m high,
1. 40 m wide.

Russolo painted a world of speed and machines

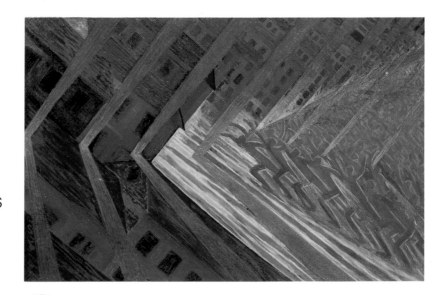

Organised around aggressive ideas, Futurism, a movement to which not only a number of artists but also many workers subscribed, expressed itself through the means of virulent manifestos. It wanted to play an active role in the changes of the modern world, and joyously celebrated the era of the machine and technology.

Musicians, writers, painters, and sculptors attacked the methods of the Old World, and developed new artistic and political theories.

▲
Russolo,
The Revolt (1911).
Oil on canvas:
150 x 230 cm.
Haags Gemeente-museum, The Hague.

The meeting of pictorial dynamism and social activism. "Beauty is born of struggle," Marinetti declared.

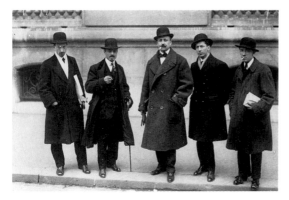

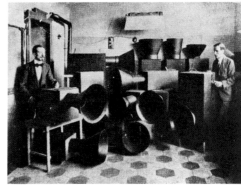

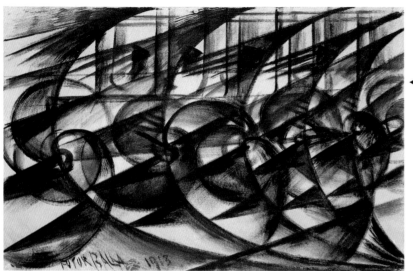

◄ **Giacomo Balla**
(1871–1958).
*Speed of an
Automobile + Light +
Noise* (1913).
Tempera,
watercolours and
Indian ink on canvas:
70 x 100 cm.
Stedelijk Museum,
Amsterdam.

The triangle is
the most dynamic
form imaginable.
The painting leans
towards an abstract
simplification.

In 1914, on the eve of the First World War, intellectual circles all over Europe were affected by this new role which artists were giving themselves: they now wanted to participate actively in social reality. In Rome, in Milan, in Florence, all means and methods were employed by the artistic avant-garde to express their convictions – posters, tracts, pamphlets, meetings. In the street, on the stages of theatres, or in factories, these noisy activists, led by Marinetti, were committed to defending modernism and its emblem, speed.

in the service of a theory

The Futurist painters used their art to illustrate their theories. In the tradition of the Symbolist painters, they treated images as allegories, using colour as the *pointillistes* had, or decomposing movement into facets like the Cubists.

Bodies no longer had substance; their chief preoccupation was representing an idea, the effects of movement in light. Form was captured in motion. Speed was expressed according to a fixed formula that each painter interpreted in his own way.

◄ Russolo (in bow tie) with one of his collaborators and *intonarumori*, musical instruments of their own invention.

Each of their unusual instruments corresponded to a different sound: there was the glug-glugger, the crackler, the hurler, the thunderer... In 1914, Russolo gathered 18 of them together for a memorable concert: the hall was evacuated by the police in the end!

Avant-garde and protest
Futurism was the first avant-garde artistic movement which was interested in music and politics as well as painting. During the First World War, Europe's social, cultural and moral discomfiture deepened. The Futurist trend began to seem almost like a revolutionary movement.

57

Futurism, or the dream of a total art

Poetry, painting, sculpture, theatre, architecture, fashion, decoration, photography, music... All kinds of experiments were tried in the name of Futurism, which exalted the enthusiasm of the individual as against tradition and the old rules.

Futurism embraced all aspects of daily life, including even the culinary arts: great importance was attributed to the aesthetic aspect of food.

an appeal to the senses

The poet Marinetti, thinker and leader of the movement, proposed his theory, *Motlibriste* ("Free wordplay"). Playing on the actual sound of words, their printed image, he produced a poetry that was both resonant and graphic, disarticulating grammar in favour of sound, onomatopoeia...

Futurism dreamed of a total art, demanding the co-operation of all the senses, in which paintings were the visual equivalents of sounds, noises, or smells that could be concave or convex, triangular, yellow, red, green, indigo...

Russolo the musician

When Russolo gave up painting, it was to return to his first discipline, music. His theories, the instruments he invented, *intonarumori* and *romorarmoni*, would make a great impact on composers such as Igor Stravinsky, Maurice Ravel, and other musicians, even into the 1950s.

Russolo wanted to tear down the wall separating the universe of harmonious sounds from that of simple noise. Between the two wars, each concert that he gave in Italy, London or Paris was an event. Yet he remained isolated and misunderstood.

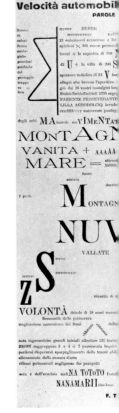

◄ **Umberto Boccioni** (1882–1916), *Single Forms within the Continuum of Space* (1913). Bronze. Mattiali Collection, Civita d'arte moderna, Milan.

This sculpture is one of the most famous symbols of Futurism. It expresses energy through the stretching out of volumes in space.

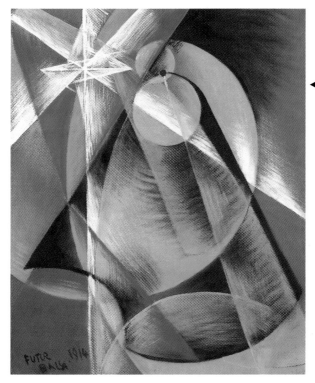

◄ **Giacomo Balla** (1871–1958), *The Planet Mercury Passing in Front of the Sun, Seen through a Telescope* (1914). Oil on thick-grained paper: 61 x 50.5 cm.

The Futurist dynamic attained a celestial scale and invaded cosmic space which, in 1914, was still an unthinkable dream.

Sensation itself
"The gesture that we want to reproduce on the canvas will no longer be a fixed moment within the whole of universal dynamism. It will be, quite simply, dynamic sensation itself." This was one of the central tenets of the *Manifesto of the Futurist Painters,* published in 1910, and signed by Russolo, Carrà, Boccioni, Balla and Severini.

We declare that the splendour of the world has been enriched with a new beauty: that of speed. A racing car, its trunk decorated with thick tubes like snakes with explosive breath, is more beautiful than The Winged Victory. First Futurist Manifesto, 1909.

The Futurist impulse was very soon to find an echo in all of Europe. In the upheaval of the start of the century, it showed that artists, just like other intellectuals, could participate in the great public debates of the day and make their voices heard.

The movement sustained the idea that art can, and must, combat social conservatism and participate in the construction of a better future. Art must be tied to life. The painters proved it when they reflected in their work the world around them, and used art to promote their ideal of a cultural model.

Between 1910 and 1920, during the revolutionary period, Russian artists continued the Futurists' experiments. Their place in society was decidedly no longer that of the painters of the previous century. By taking an active part in social life, they invented the figure of the modern artist, the artist committed to social causes.

59

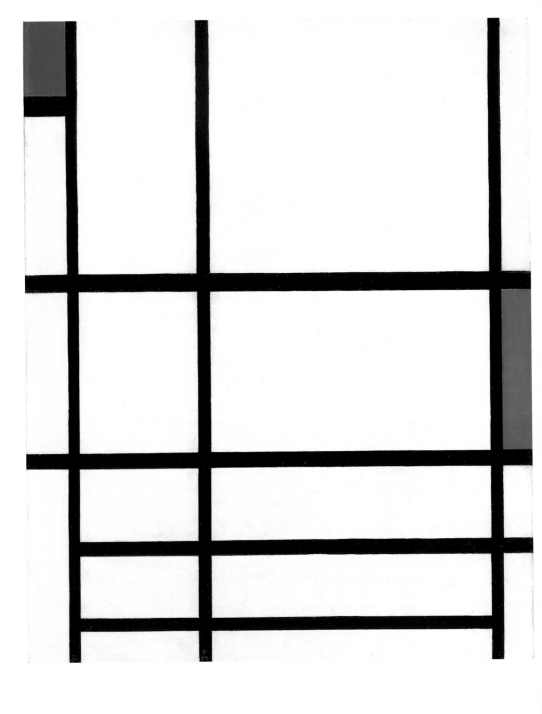

MONDRIAN
pure form

▲
Self-portrait of
Mondrian at 40.
Charcoal. Haags
Gemeentemuseum,
The Hague.

A disciplined theoretician, a determined innovator, a pioneer of geometrical abstraction, Mondrian's dream was to make painting a means of transforming human reality.

A rigid black grid is set out on the painted canvas. The brush, impersonal, has cut out white surfaces with strict right angles. Each one has a different format: the black of the lines that surround them makes the white vary in intensity. What is behind the network of black lines, an unbroken and uniform surface, or boxes, compartments of varying depth?

The visual arts do not only accompany human progress; they must lead the way.
Mondrian.

a minimalist architecture

At the top, on the left, a blue rectangle, boxed in on two of its sides by the edge of the painting, seems to sink into the canvas. On the other side of the black framework, a red rectangle, also relegated to the edge of the canvas, counterbalances the blue one.

The vertical lines seem to extend beyond the frontiers of the painting. The horizontal lines, on the other hand, do not all cross the canvas entirely.

At each intersection, the eye hesitates, seeks another focus, following the straight lines. The observer's gaze circulates, following the rhythm of the black structure, from the closed surfaces in the centre to the open spaces on the sides. The eye is attracted by the blue and the red, primary colours whose effects are all the more concentrated as their surface is limited.

This is what Mondrian was seeking, as he multiplied his experiments with geometrical grids: this rhythm of the simple truth of forms.

Mondrian, painter of flowers
Life was difficult and to make ends meet, Mondrian painted watercolours of flowers whose realistic style was very far from the work he was to become known for. Around 1925, he gave up this activity, which served chiefly to pay the bills, to devote himself exclusively to developing his new aesthetic theories, which would later become Neo-Plasticism.

◀ **Piet Mondrian**,
Dutch painter
(1872–1944),
Composition II (1937).
Oil on canvas:
75 cm high,
60.5 cm wide.

61

Mondrian constructed a world of right angles

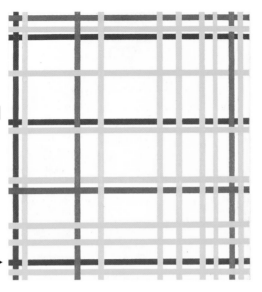

Mondrian ▶
New York City I
(1942).
Oil on canvas:
119 x 114 cm.

The black lines have given way to a coloured grid. "Yes, now, there's a little more boogie-woogie in there," said the painter.

▲
Mondrian
New York City,
Classical Drawing no. 6
(c. 1941).
Lead crayon on paper:
22.8 x 21 cm.

Mondrian sketches out the painting, seeks the rhythm of the lines. Structuring them is then part of the process of composition.

The formal simplification that Mondrian attempted to achieve was a spiritual quest. As he saw it, the artist's purpose was to formulate the rules of harmony governing the world, and thus help humanity escape from life's more tragic aspects. Art should move away from individualism and seek the universal. With this purpose in mind, Mondrian expressed, in his painting, his vision of the world: an almost scientific coldness and a philosophy marked by the influence of mystical thought.

Mondrian ▶
Red Tree
(1909–10)
Oil on canvas:
70 x 99 cm.
Haags Gemeente-museum, The Hague.

Studies on the simple theme of the tree lead to the constitution of an autonomous network of lines and colours.

Jazz and fox-trot
Mondrian was not always as forbidding as his reputation would have us believe: he danced the fox-trot tirelessly and loved one of the most energetic rhythms of classic jazz, the boogie-woogie. Indeed, he gave this title to several paintings of his last period, in the United States.

Like the taut lines, which define the rhythm of his paintings, Mondrian's work follows an unbroken path. At the turn of the century, to achieve greater purity, Mondrian little by little moved away from the Neo-Impressionist landscapes of his early years. He was attentive to the lessons of another master of colour, like himself Dutch: Van Gogh. But when, in 1912, he discovered Cubism, his geometrical predilections were reinforced.

the + and the -

He then began to conceive of an art that no longer was rooted in an image of the outside world. Soon, his paintings were constructed solely on the relations between their basic elements: horizontal lines, vertical lines, the three primary colours (red, yellow and blue), and the simplest of signs, like a plus and a minus.
Mondrian developed an independent language, based on logic alone, and which owed nothing to external forms. In sum, an abstract language, in the true sense of the term, even if one can imagine detecting in the "plus" sign a stylised memory of a traditional Dutch landscape: a windmill on a hill, or the arrow of a church steeple tower outlined against a flat horizon.

Mondrian
Silvery Tree (1911).
Oil on canvas:
78.5 x 107.5 cm.
Haags Gemeente-museum, The Hague.
▼

Mondrian
Apple Trees in Blossom
(1912).
Oil on canvas:
78 x 106 cm.
Haags Gemeente-museum, The Hague.
▼

63

the artist and architect of the future

Mondrian dreamed of a larger-than-life purity, a man-made paradise. With such an ideal, it was natural that his commitment would go beyond painting to touch all aspects of life. Mondrian led a serious, ascetic artist's existence, part scholar, part wise man.

frivolous diagonals

The philosophy behind his paintings soon came to be known as Neo-Plasticism. According to its principles, which imposed the strictest immobility, the oblique line was considered an unacceptable frivolity: the disequilibrium introduced by a diagonal indeed created a completely different dynamic, more exterior to the painting. In 1917, Théo Van Doesburg founded with Mondrian the group and the review *De Stijl* ("Style"). Their aim was to contribute to the development of a new aesthetics that would unite art and architecture. This painter, architect, editor, and polemicist was also a tireless activist: through his travels and his contacts he managed to spread the new philosophy as far as the Bauhaus and throughout the world.

Line, colour, and form being the highest degree of simplification, it is up to the young to preserve them, to compose them and to establish them, in accordance with their individual taste.
Mondrian.

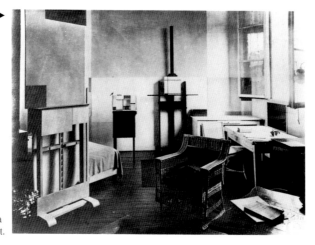

Mondrian's studio, in Paris, in 1926. Photograph.
"In Mondrian's studio reigned a kind of mystery of cleanliness, a perfection which was frightening to all that is confused and messy in us, the unimaginable virginity of interstellar space," said the critic Michel Seuphor. The artist's workshop was decorated along the same lines, using the same principles, as his art: more than just a way of life, it was a statement, a commitment.

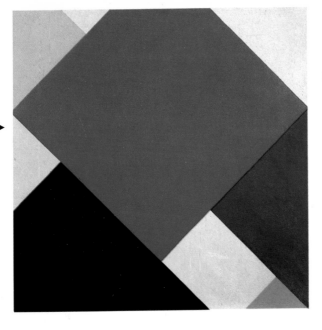

Théo Van Doesburg ▶
(1883–1931),
Counter-composition V
(1924).
Oil on canvas:
100 x 100 cm.
Stedelijk Museum,
Amsterdam.

The composition,
swung round at a 45°
angle, makes the eye
follow the diagonal
axis beyond the edges
of the painting. For Van
Doesburg, the oblique
was the expression of
modern life, which
caused a falling out
with Mondrian.

Motivated by the desire to change the reality of their
era, to purify thought and vision, painters were soon
succeeded by architects, these men who truly worked
and dealt with the dimensions of the city. In the 1920s,
with several constructions and numerous urban
planning projects, Mondrian's early companions would
influence several generations of architects through the
austere discipline of their artistic language.

Façade of the café De
Unie. Constructed in
1925 by the Neo-
Plastician architect
Oud, the café was
reconstructed in 1986,
in Rotterdam.
▼

purely and simply

**Doctor Van Doesburg
and Mr Bonset**
Van Doesburg led
an astonishing double
artistic life. A Neo-
Plastician in Holland, in
Germany he published,
under the pseudonym
of Bonset, poems and
collages in the spirit
of the Dada movement.

They liked to design flat façades, divided into geomet-
rical compartments, which absorbed doors and win-
dows. Right angles and primary colours predominated:
the lesson of the painter found its echo here. So it did
also in the rules of modern typography and book design,
in house decoration and furnishing, even in the simpli-
fication in the design of forms of manufactured objects.
As it had for architecture, Mondrian's aesthetic vision
inspired industrial design with some new basic rules:
avoiding superfluous ornamentation, it shows only, in
the purified form of its objects and constructions, the
essential structure, an approach which still marks
today's forms.

▲
Raoul Hausmann
(1886–1971),
The Spirit of Our Times
(Mechanical Head)
(1919).
Composition: wooden
dummy head and
diverse materials.
32. 5 x 21 x 20 cm.

Anti-art, or how
ordinary objects,
well-chosen,
are transformed
into an ironic and
derisive emblem
of modern man.

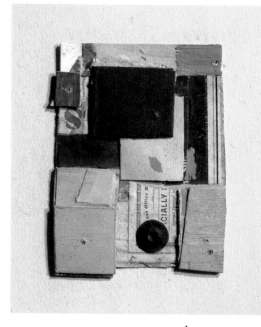

▲
Kurt Schwitters
(1887–1948),
Merz 1926–2 (1926).
Collage of paper,
cardboard, and
plywood, gouache
on cardboard:
12.5 x 9.3 cm.

The work is a
composition of
recycled objects, each
of which brings to the
composition the colour,
matter, and flavour
of its former life.

◀ **Jean Pougny**
(1884–1956),
The White Ball
(1915).
Oil painting on
wood, and plaster:
34 x 51 x 12 cm.

The object-painting is
reduced to its essential
elements. Can one
see in this ball a sun
lighting up a green
day and making night
disappear?

The work of art and the object

In the early years of our century, the work of art was reconsidered along various angles – the way it was made, its aims and its means, but also its material definition: its very nature as an object. In a world in upheaval, art found itself confronted with the objects of everyday life. The dividing line between a factory and a workshop, between the products of art, of craft, and of industry, was not always easy to define.

The century inaugurated by the Eiffel Tower, in 1889, was that of industrial production, of a consumer society. The 20th century was soon invaded by manufactured objects that were an integral part of daily life. Complex objects, which could be handsome even when mass produced and distributed.

Did industry want to take over the privilege of artistic know-how and talent? Could the machine improve on the hand of man? The very idea of a rivalry, or competition, affected the attitude of artists, and their production.

Modern artists were to react against tradition, which prized technical competence over the force or originality of the subject – a tradition that the *pompier* painters of the nineteenth century pushed as far as it could go. 20th-century artists would go against this tradition of technical prowess.

Freed from the constraints of commissioned works, they found their inspiration willingly in daily reality, which gave them not only ideas, but also images, materials, and objects. Taking an interest in the power of objects, in the meaning or ideas they carried, placed the painters in a role that until then had been reserved to poets and philosophers. Their production was no longer dependent on specific and immediately identifiable techniques. Distancing themselves from their work, artists could deliberately mock themselves, practising not only self-deprecation but sometimes even self-destruction, with works that scarcely even resembled paintings any longer.

Man Ray
(1890–1976),
The Gift (1921–63).
A clothes iron with
nails, a 1963 original
copy based on
a lost model:
17.5 x 10 x 14 cm.

Designed in 1921,
during Man Ray's
first exhibition in
France, this was a gift
from "the American
friend" to the Parisian
Dadaists who had
welcomed him.

▶

Alexander Calder ▶
(1898–1976),
*White Disc, Black
Disc* (1940–1941).
Painted wood and metal,
steel stems, motor:
124 x 92.5 x 45.5 cm.

"After a visit to
Mondrian," recounts
Calder, "I tried to paint.
But iron wire, or
something that can be
twisted or torn, does
a better job of expressing
my form of thought."

◀ **Joan Miró**
(1893–1983),
*The Object of the
Setting Sun* (1935–36).
Trunk of a carob
tree, painted, with
metallic elements:
55 x 44 x 26 cm.

Farce or work of art?
Miró himself asked
the question about
this object possessing
an unusual magic:
that celebrated by
Surrealism, when
things and objects
begin to speak.

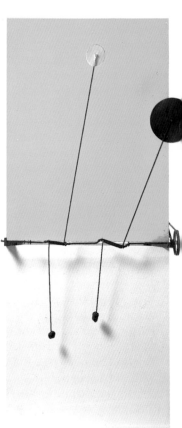

If a project demanded technical skills which were beyond those possessed by the artist, he would entrust its construction to a craftsman, a worker, or an engineer. The artist's role no longer necessarily involved the technical mastery of his work, but rather the evocative force it vehicled. And for the work of art to achieve its aim more directly, it was just as well to rid it of its "sacred" aspect. The work itself became banalized, and could even be confused on occasion with everyday household objects. Very quickly, collage and assemblage became means of associating the workaday world with the painting. Wallpaper, plain or with a pattern, fragments of objects, whole objects: a bit of reality was introduced into painting, even if often it was ordinary and with no innate value. After all, gold does not an art object make! The raw materials had little importance. To become a work, what mattered is that the object produce an effect on the observer: surprise, amusement, indifference, anger, sadness, memory, confusion, frustration.

Traditionally, the artist created forms. He was now responsible for the forms that he found and chose to show, or for their associations. He had become an arranger and assembler as much as an inventor. The art of the past appeared to answer to pre-established rules and restrictions. Modern art, on the other hand, had as its central rule...not to have any! It sought out the new, the unpredictable. It transgressed, and provoked. "Beautiful like the chance meeting of an iron and an umbrella, on a sewing machine," declared, as early as the 1870s, the poet Lautréamont. And so the Cubists stuck together their bits of newsprint, and the Dadaists assembled anything they ran across. Marcel Duchamp replaced, purely and simply, the object of art with an ordinary object, which became enigmatic through the simple fact of being displayed in a certain way. With irony, he thus raised to the rank of art object various industrial bits and pieces – what counted for him were the ideas and images produced.

Not all the artists of our century followed such radical paths. But for all, the status of the work of art was marked by absolute derision, the ironic reduction of the Dada movement. Freed from the central requirement of "the well-crafted work", their creations expressed in other ways the questions that artists ask, by taking, when they wanted, the form of the most banal object imaginable.

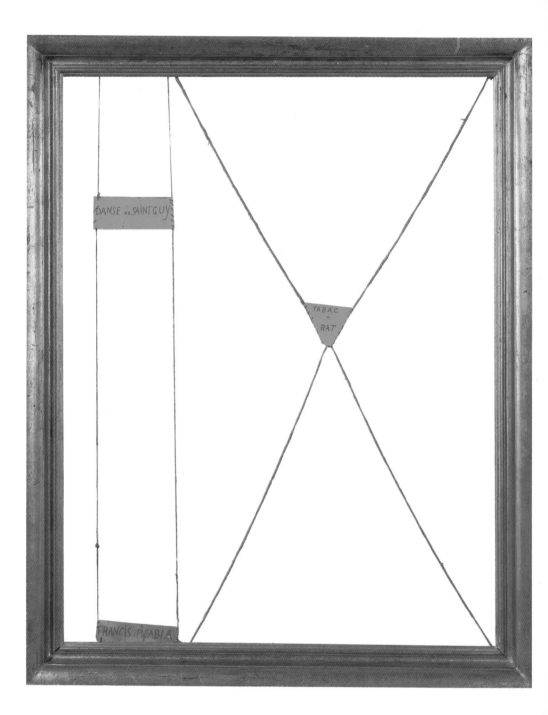

FRANCIS PICABIA
the picture with no painting

An unpredictable painter, a wealthy heir, a father, a collector of magnificent automobiles: Picabia was all of these. From Paris to New York, he loved to provoke scandals in the art world, with his friends the Dadaists.

"This painting was made to be hung in a room, from the ceiling; it was meant to remain transparent. The strings accompanied the movement of what was happening outside of the frame." This is how Picabia described this provocative object, titled alternatively *Tabac-Rat* or *Danse de Saint-Guy.*

The only thing that is indispensable is the superfluous. Picabia.

I carry around with me at all times a little golden frame, through which I contemplate the sunset. Picabia.

◄ **Francis Picabia**, French painter, illustrator, and writer (1879–1953), *Tabac-rat* or *Danse de Saint-Guy* (1919). String, cardboard, and frame: 104.5 cm high, 85 cm wide.

art on a shoestring

In 1922, Picabia proposed three works for the Salon des Indépendants. Only this *Danse de Saint-Guy* was accepted. Yet almost the only thing it had in common with a painting was the frame! Four bits of string crisscross the open space, forming simple geometrical figures. Pieces of cardboard are sewn to it. It bears the name of Francis Picabia, and several enigmatic inscriptions. Why the "Dance of Saint-Guy", an expression designating the agitation of madmen, or at least highly nervous people? Why the phrase "Tobacco-Rat"? The painting resembles a silly, hastily thrown-together object which has required no technical prowess, no materials of quality. There is no painting, no canvas, no form, no colour: it is more the absence of a painting than it is a painting; perhaps an anti-painting. And yet... the frame serves to delimit a landscape; or the portrait of whatever is behind it. With the geometrical division of space, Picabia wants to show a new form of reality.

The art of the breach
In turn impressionist painter, Cubist, Dadaist, Surrealist, academic and Abstract painter, Francis Picabia made an art of breaking with what ever had preceded. His work is one long series of about-faces, not only with regard to the traditions of art, but even to his own previous styles and manners! "Our head was made round so as to allow our thoughts to change direction," he said.

71

Picabia mixed art and life

Strange and unexpected, his work plunges the observer into uncertainty. The world bristles with unanswered questions. We are far from a universe of timeless values, of eternity, heedless of the centuries to come. The artist is no longer someone who creates a handsome art object, but someone who communicates, using and transforming an everyday object, a sign of his own life, an expression of himself.

▲
Picabia behind a version of *Tabac-Rat*, against a black background. Photograph.

irony and liberty

Picabia's art is concerned with the impalpable present. "Art has only two dimensions: height and width. The third dimension is movement – that is, life," he explained.

Behind *Tabac-Rat*, the artist wanted to place a little wheel that would be powered by the motions of white mice. Humour, paradox, a moment's inspiration, these were Picabia's arms for combating clichés and preconceived notions, shattering the conformism of thought and creation, shaking up the observer.

Dada
Between 1916 and 1924, a protest movement of intellectuals in revolt against bourgeois society and its culture saw the day. The movement sought to free the individual through humour, criticism, satire, and poetry. Derision was a theme of the movement, found even in its own childish name, borrowed, it would seem, from the brand name for a hair lotion!

Make your life a work of art!
Picabia.

A painting must be an expression of life. Picabia proves it himself here.

Dada, what tendency?
Between 1916 and 1924, Dada was talked about everywhere, from Zurich to Berlin to Paris to New York and beyond. The name of a group, the title of a publication, a slogan, a war cry, Dada was all of this. What it was not was a structured, homogeneous movement. Its history was punctuated with disputes, separations, reunions. As for Picabia, he broke with the Parisian branch of the Dada group in 1922.

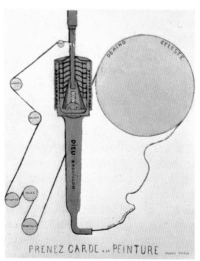

◄ **Picabia**
Beware of Painting (1921).
Oil on canvas:
91 x 73 cm.
Moderna Museet, Stockholm.

Picabia simultaneously mocks and celebrates the machine, and painting.

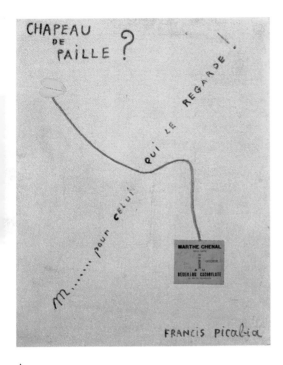

▲
Picabia
Straw Hat? (1921).
Oil, string and
cardboard stuck
to the canvas:
93.5 x 73.5 cm.

This was one of two
paintings refused
by the Salon des
Indépendants in 1922.
Picabia used this
rejection as an excuse
to engage in a polemic
in the press. He
published an open
letter in which he
described his painting,
taking care to note
that the phrase,
written across the
middle of it, should
read: *Thanks to
whoever looks at it!*

This was the philosophy of the Dada artists: they wanted
to do nothing that was expected of them, and certainly
not in the domain of art! Revolted by the horrors of the
First World War, painters and writers joined together and,
in response to the absurdity of the world around them,
they answered with illogicality, farce, mystifications.
They mocked everything: art, themselves, the public.
This entailed not just a refusal of what existed; they also
were determined to renew artistic practices, to deliver
them from the traditional rules, and especially from the
expectation that art had to be "beautiful". For the
Dadaists, art needed to remain in contact with life and
the modern world. Machines, industrial objects, know-
how and technical progress were more and more cen-
tral to life. Art objects, for their part, challenged these
developments: designed, as it were, against the rules,
provocative, poor, they seemed sometimes almost hap-
hazard or accidental. To the complexity of the modern
world, the artists opposed their spontaneity. Their
creations defied all rules. They were producing anti-art.

▲
Picabia
Picabia is an imbecile.
Picabia distributed
this tract as an
invitation to the Salon
d'Automne in 1921.
In it, he answered
the attacks of another
branch of the Dada
group, organised
around the poet
Tristan Tzara, one
of the most active
members of the
movement. Invective,
provocation, self-
mockery: this was
the tone of Dada.

Duchamp, or when everything becomes art

Another famous Dadaist, Marcel Duchamp, began his artistic career as a painter. In a few years' time, he had multiplied his artistic experiments, joining for a time the avant-garde Fauves, Cubists, and Futurists. But, from 1916 on, he began to go even further, breaking with the gravity and seriousness which still surrounded art like an aura – in fact, he would end by giving up painting in 1923.

ready-made works

Painting must not be exclusively visual; it should also speak to the mind.
Marcel Duchamp.

No more technique, no more respect for conventions and for the comfort of the eye. Enough of the smell of oil paint! All it takes for a work to exist is a little bit of handyman carpentry work: this was the era of the "ready-mades". Marcel Duchamp began to champion a "dry" art: the art object was replaced by an industrial object. The artist stuck a hanger on a particular spot on the ground, or baptised a toilet with the title *Fountain*. He no longer invented form or matter or colours: he recycled, associated, dreamed up a title, signed, and most important, he displayed what he had done. For Duchamp, the work of art exists through the eye of the beholder.

▲
Duchamp and Man Ray playing checkers on a roof in Paris. A scene from René Clair's film, *Entr'acte*, made in 1924. With its humour and its whimsy, the film indeed shares the Dada spirit. A few moments later, Picabia will chase them away by spraying them with water from a hose.

◄ **Marcel Duchamp** (1887–1968), *Box in a Suitcase* (1938). Assemblage of various objects created by the artist using elements of his own works: 40.7 x 38.1 x 10.2 cm.

The artist put together his works in a portable museum that could be contained in a suitcase. Marcel Duchamp's own work, in reduction.

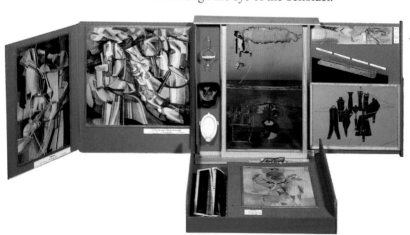

Marcel Duchamp wanted to disconcert this beholder by giving the art object unexpected character, making it something borrowed from daily life. After all, in the era of factories, what was the point of making these easily dirtied and laboriously hand-made productions, known as works of art?

What I would like is to be able to invent without painting.
Picabia.

the object and the modern world

For Duchamp, for Picabia, for all those who participated in the Dadaist fervour, the artist was no longer necessarily the master of a technique. He was an individual who chose, displaced, manipulated and arranged objects. He could decide "this is art" and display unpredictable and unlikely objects which had a title, a base, a frame, and a signature...

The work of art thus freed itself from style and technique. It was no longer only a creation, but often meant taking and reusing a banal object. This was the era of "anything goes", as its detractors still say today. It was a time when it was possible, if one knew how to look, to seek out and find in any object, any form, a meaning, a question or a sensation that was new and unusual, that was a portion of life.

For me, all the pleasure of painting is in invention.
Picabia.

Marcel Duchamp ▶
Bicycle Wheel (1913).
Fork and bicycle wheel, stool:
126.5 x 31.5 x 63.5 cm.

This mobile sculpture – the wheel actually turns – with base incorporated, was one of the first of Duchamp's "ready-mades". Is it still possible to judge a work of this nature in terms of taste or beauty? From the department store to the museum, all that is needed is the artist's choice, and the observer's appreciation.

art or anti-art?

With Dada, the most serious works lost a little of their sacred character to become objects like any others. Soon, museums began to accept these unclassable works. And, as the century wore on, numerous artists retained this spirit of irony, this apparent provocation and nonchalance. To the point of making anti-art a tradition of modern art! And of opening today's art to the most improbable practices....

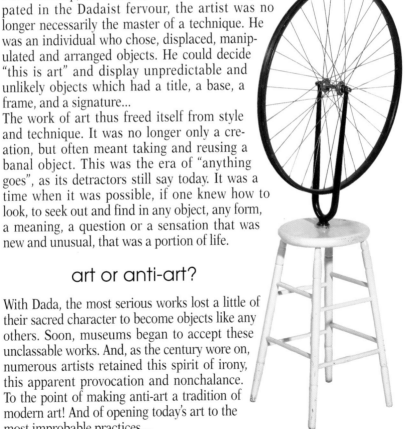

75

André Masson (1896–1987). *Dead Horses* (1927). Oil and sand on canvas: 46 x 55 cm.

On the canvas, painted in places and laid flat, the artist projected glue and sand. When he brought the painting back to an upright position, the surfaces of glued sand combined with the coloured zones to trace signs.

Jean Fautrier (1898–1964). *Gentle Woman* (1946). Covered with Spanish white, glue, coloured powders and oil on canvas: 97 x 145 cm. The successive layers of painting, applied directly by pressing tubes, form a relief, a whitish mass which emerges from a surface coloured with soft tones. ▼

▲

Georges Mathieu (born in 1921). *Lothaire Abandons the Haute-Lorraine for Othon* (1954). Oil on canvas: 97 x 162 cm.

The paint spurts, runs, forms thick patches. It is the result of a spontaneous gesture, without premeditation, the direct and improvised expression of the painter's emotion.

Painting as materials

Habit has made us forget that the word "paint" has at least two meanings. It designates both the coloured materials, which come out of a tube, and the various ways they can be used.

Artists didn't need to wait for modern times to discover that this material itself offers infinite possibilities to the eye. From the beginning of the 16th century, in his *Treatise on Painting,* Leonardo da Vinci evoked the "confused forms" that one can make out in clouds or muddy waters, on walls covered with stains or composed of mixed stones.

There is much in nature to stimulate the observer's spirit of invention: natural or accidental forms, stains, traces, make possible all sorts of visions and constitute so many signs to be interpreted in a given environment. It is then up to the observer to read them, to recognise in them a form or a gesture.

In the 20th century, stains did not mean anything more or less than in Leonardo's time. But the experiments of artists, their games with painting taken as a concrete material, were accepted as fully legitimate works of art.

Already, the Impressionists, and Van Gogh, and Cézanne, all of those who were to become the first modern painters, showed paint as a visible material which no longer hid itself, which in no way tried to melt into the perfectly unified surface of the canvas.

Their detractors in fact often criticised them for making paintings that were unfinished or approximate. It is true that classical aesthetic theory demanded that all the traces of the process of composition of a work be eliminated from the final result, that the sculptor polish the marble, that the painter conceal his brushstrokes, if need be under a layer of gloss.

Abandoning this convention, modern painters were far more direct. They preferred a straightforward, visible, free touch to the elegance of a surface that was polished like a mirror, shiny and sophisticated. It was as if they sought to show what went on behind the scenes, to expose the processes of the work-in-progress as well as the finished product.

◀ **Simon Hantaï** (born in 1922), *Mariale 3* (1960). Oil on canvas: 290 x 210 cm.

The canvas is folded, crumpled, then painted. The artist discovers the final painting when he unfolds it.

▲
Marolo Millarès (1826–1972), *Pintura no. 2* (1960). Assemblage of bits of canvas, sewn to a hemp canvas, string, acrylic paint: 162 x 130 cm.

The canvas becomes one of the materials of the painting. Millarès' "tortured rags", blackened with paint, are dramatic and threatening.

◀ **Bram Van Velde** (1895–1981), *Untitled* (1962). Gouache on paper: 122 x 127 cm.

The gouache is easily diluted; it runs and penetrates the paper. Dry, it continues to give an impression of fluidity, fragility.

78

The art of today's painters is an art of experimentation. Artists no longer seek to dominate with their technique, to show themselves as masters of this matter which is unique to them: painting. Today, painting no longer means only domesticating and conquering the art of painting but also making use of its concrete, material aspects, its good points like its bad. It means leaving its unpolished aspect, letting all sorts of direct evocations and emotions show through.

The art of the 20th century thus rediscovered prehistoric art or the drawings of children, in a word, all the practices in which technique takes a secondary role to the desire for spontaneous expression.

In and of itself, materials are neither beautiful nor ugly. They acquire form through painters' gestures, whether they apply a delicate brushstroke or a vigorous one, with a spatula or their bare hands, sometimes leaving visible signs of the pleasure he had playing with it, touching it.

Painters' works thus begin when they choose their paint. It can be fluid or solid, docile or rebellious, limpid or dry, smooth, thin, harsh, thick. The question of consistency is decided on by the painter in function of the effect, the type of "writing" being sought: the reserved, precise line, a rapid splattering motion, or a hesitant one, which drips slowly.

The gesture is inscribed and leaves its mark, in the thickness of the surface, if the painting is worked in a paste-like paint; and in the trace of movement, like a trail, if the painting is worked in more liquid paint. Like the hand-written word, painting tells us something about the person writing. Each accident or incident of the material on the painted surface is full of meaning and feeling.

And, very quickly, in the name of a liberty of means, the curiosity of artists would go beyond traditional materials. Already Manet, then Picasso, used Ripolin, house and building paint. Soon painters would try acrylic and various other sorts of industrial paints. They began to do without traditional tools. Better yet: they sometimes didn't even need paint any more to do their paintings! It remained for each canvas to prove through its own merits that it had some connection with art.

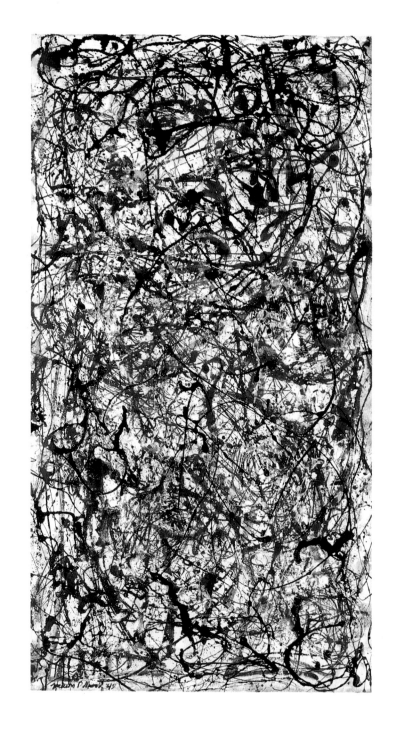

JACKSON POLLOCK
nothing but paint

In the America of the 1950s, Jackson Pollock had a lightning career. In less than a dozen years, this child of the Far West became the first representative of a specifically American artistic avant-garde.

Sometimes I pour the paint directly from the can. I like to use a very liquid paint that I let drip slowly.
Pollock.

Arabesques, drops, puddles, splashes, stains... Their network extends over the entire surface of the painting. In places, the canvas shows its colour, beige. Then three layers of paint come to join it: white, grey, and black; or rather, three networks, superimposed and interlocking.

in the labyrinth

Is there a beginning and an end to this jungle of paint? It is difficult to determine a point of departure and of arrival; the eye follows the drippings, which stretch out and overlap on the surface of the canvas. Nothing indicates that one can cross this curtain of paint or decipher it: if there was a figure that presided at the origin of the painting, it has been drowned in the enamel, progressively buried in the drippings.

For no brush produced these interlocking lakes. No hand designed these forms. Paint alone traced these signs, these stains, these puddles which cover the entire canvas, and even seem to extend beyond it. As if the painting represented only a part of a much larger entity. Marking the trace of the artist's passages over the canvas, the painting paints itself, once the painter has freed it, or rather, left it to itself, dropped it, in the literal sense of the word! This is, more or less, how Pollock proceeded.

The stuff of a hero
Due to the originality of his painting, but also to a tortured life and sudden, brutal death in a car accident, Jackson Pollock appears as a tragic hero of modern art, almost a kind of American Van Gogh.

◄ **Jackson Pollock**
American painter and illustrator (1912–56), *Number 26 A, Black and White* (1948). Enamel paint on canvas: 2.05 m high, 1.22 m wide.

81

Pollock let the paint drip

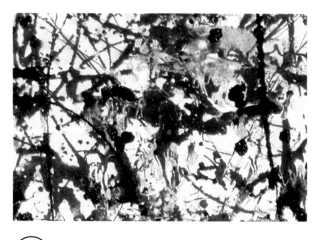

On the canvas laid out flat on the ground, Jackson Pollock developed a singular technique, called "dripping". He began to use it systematically around 1947, and developed several variations on this theme over the course of the years. He mixed foreign elements with the paint (sand, broken glass) to vary its degree of fluidity. The appearance of the painting depends, indeed, totally on this fluidity, since the paint organises itself on the surface, runs, spreads out, dries, in function of its thickness. Thus, sometimes, the drops seem still brilliant, fresh, as if they had just been applied.

consistency and appearance

Pollock used industrial paints, meant for the bodywork of a car, for instance: yet another way of rejecting traditional techniques. He thus abandoned the tools of the painter for simple sticks that he soaked in paint, then shook over the surface of the painting. He also used cans and pots of paint with holes pierced in them, from which he let the liquid drip. He then had only to harmonise the paint's consistency with his tools, and let things happen.

Painting, street-scale
Pollock devoted himself to "mural" painting during the black years of the Depression in the 1930s. In America, this form of painting was a tradition going back to the pre-Columbian period! In Mexico and the United States, muralists painted on a public scale, for the entire community.

▲
Pollock in action,
1949. Photograph.
The photographer
is the painter's
accomplice: he shows
the public the work
of the artist in his
studio, helping to
make it understood.

Pollock ▶
*Painting (Silver over
Black, White, Yellow
and Red)*, (1948).
Enamel on paper stuck
to the canvas:
61 x 80 cm.

A small "dripping".
The succession of the
passages of colour
gives depth to the criss-
crossing of the drips.
The work is fairly small,
but this jungle of
painting has a cosmic
inner dimension.

Pollock's work consisted in balancing the control that
he as artist exercised over the painting and the freedom
left to the materials themselves. Each of his move-
ments added a thread to the spider's web, whether the
effect was that of a to-and-fro, a gentle swaying, or a
whirlwind. The painting does not vehicle an image. It is
a surface which registers the time, the duration of the
painter's efforts. It marks a moment in the artist's life.
When the painting is brought to an upright position,
space is altered: what was horizontal becomes vertical,
accentuating still more the painter's individuality. He
noted: "I like to work on large format paintings; I feel
more in my element." Peggy Guggenheim, the Amer-
ican heiress, who had a passion for modern art, com-
missioned one of his first large-scale paintings, which
would bring the painter's originality to the attention of
the art public.

**Painting like
the Indians**
Pollock was fascinated
by the art of the
Navajo Indians, who
drew ritual or magical
figures on sand floors.
It is they, he said, who
made him understand
why one should paint
on the ground.

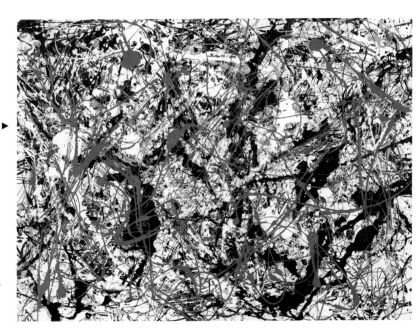

83

painting, or the expression of an inner violence

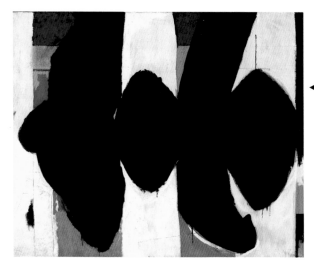

With Pollock, painting provided a record of the artist's existence. It showed, concretely, his spiritual confusion, his inner tensions. Like the experiences of automatic writing undertaken by the Surrealists, Pollock's gestural painting sprang from the unconscious, and expressed his inner anguish. In the labyrinth of stains, the painter sought his own truth, and enabled the observer to seek his.

With the upheavals brought about by the Second World War, the world was transformed, and the role played by

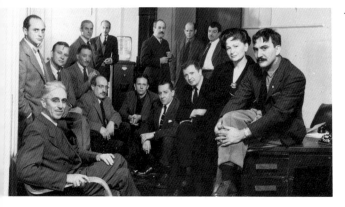

◄ The group of the "Irascibles", 1957. Photograph.

The "Irascibles" was the name given to the New York avant-garde by the American press. From left to right, in the last row, de Kooning and Pollock are first and fourth. Motherwell is the second, in the centre.

My painting is a direct kind of painting. My method in painting results from the natural growth of a need. I want to express my feelings rather than to illustrate them. Pollock.

◀ **Willem de Kooning**
(1904–97),
Woman (1952).
Charcoal and pastel
on paper:
74 x 50 cm.

The tormented lines
transform the image
of the female body
into a strange pagan
idol. "I don't know
the difference
between painting
and drawing", said
the artist.

**The War of
the Avant-Gardes**
In the fifties, the
European and
American avant-
gardes were rivals.
In the United States,
several tendencies –
Abstract Expressionism
or action painting –
were grouped together
under the name of the
New York School,
to distinguish them
from old Europe, with
its "tachiste" painters,
its informal art,
and various abstract
tendencies, loosely
joined together under
the name of the Paris
School.

the United States was increasingly dominant.
American artists joined together to impose their art,
and its originality, in their own country, but in Europe
also, where modern painting had been born.

a New York avant-garde

The idea that there was a painting that was specif-
ically American soon took root. This gave artists the
opportunity to break with the art history of the Old
World. While Pollock was experimenting with his
techniques, other artists were also undertaking inno-
vative approaches, with the support of critics, art
dealers and museums. Without any organised theory
or agenda, without a program or manifesto, painters
everywhere were renewing the fundamentals of art.
Some, like Mark Rothko, revelled in colour. Others, like
Robert Motherwell, explored "gestural painting". Of
Dutch origin, Willem de Kooning remained situated
between the figurative and the abstract. Attentive to
gestures, conscious of paint as material and element, he
never gave up the image and representation altogether.

Europe in New York
In the New York of the
1940s, the European
influence was very
strong. Many artists
arrived in the U.S.
as refugees, driven
from Europe by
Nazism: Fernand
Léger, Piet Mondrian,
and Surrealists such
as André Masson,
Salvador Dali, Max
Ernst. It was above all
for these artists that
Peggy Guggenheim
opened her gallery
in 1942.

85

JEAN DUBUFFET

painting in the raw

▲
Jean Dubuffet, c.
1970, photographed
at the age of 69.

<u>Using the most varied materials and techniques, Jean Dubuffet invented an art with no respect for conventional rules, an art answering to a deep inner need for expression.</u>

Art must be born of its materials, and be nourished by inscriptions, by instinctive lines.
Dubuffet.

The painting is filled with soft, heavy forms, in relief. On this rough surface, fine black lines trace an inextricable network. The mass of paint seems to be coloured in depth. It shines with a metallic brilliance, in tones of earth and oil.

Soon the eye perceives a menagerie of figures stuck to the canvas: long-legged birds, frogs, imaginary beings, a bit monstrous, mixed with vegetal elements, leaves in decomposition in the middle of a living earth.

an imaginary geology

What exactly is this painting? A strip of earth, a raised map of a tormented region? And the lighter strip at the top of the picture, near the frame? Should this be seen as a shore, with its bays and capes, the line of the horizon, a slope, a hill? Or, yet another possibility, a geological discovery, revealing fossils captured in their earthy bedding? Towards the centre, a man accompanied by his dog approaches the surface. If he continues to follow on his path, he will soon reach the light above. His thin legs, his rounded belly, his head drawn with deliberate clumsiness all make him a fragile character, with an anxious air about him. This "traveller with no compass" is also the observer. Deprived of the usual visual clues, he is lost in these strange countries, the landscapes of Dubuffet's universe.

From the bottle to the brush
Originally a wine merchant, Dubuffet finally began to devote himself fully to his lively and inventive career in art when he was almost 50 years old. Gifted with the talents of a writer and pamphleteer, independent, outspoken, he never did anything as "he was supposed to". He is one of the best-known French artists in the world.

◀ **Jean Dubuffet,**
French painter, illustrator, and writer (1901–85), *The Traveller without a Compass* (8 July 1952) Oil on isorel: 1.18 m high, 1.55 m wide.

Dubuffet, a painter who plunged into materials

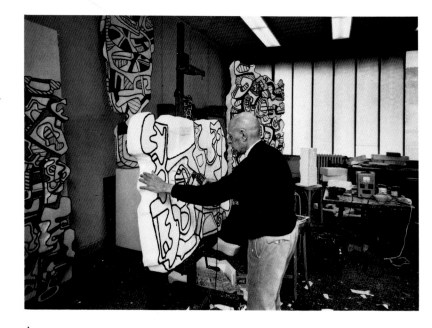

Everyone is a painter. Painting is like talking or walking. It is, for the human being, as natural to scribble on the first surface one comes across, to doodle some pictures, as it is to speak.
Dubuffet.

In the 1960s, Dubuffet invented a language of forms he called the *"Hourloupe"*, a name suggestive of several other words in French: *hurler* (to howl), *huluter* (to hoot), *loup* (wolf), *Riquet à la Houppe* (a character from a children's tale) and *Horla*, the supernatural guest in a story by Maupassant. The Hourloupe was born in the drawings that the artist, when he was on the telephone, doodled without thinking. These hatchings gave the painting the appearance of a striated land survey map.

In his work as a whole, Dubuffet used all sorts of techniques: graffiti, incisions, scraping, rubbing, prints, stains, collage, assemblage.... He chose to ignore the craft and skills that are traditionally those of the painter, to offer the viewer a landscape filled with various materials, in which everything was possible.

dream landscapes

He explored the most diverse materials: hairs, vegetals, butterfly wings, crumpled, chewed, dampened paper, scrap materials. He mixed sand, earth, cinders, white lead,

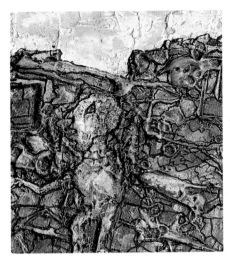

◄ **Dubuffet**
The Strayed Donkey
(1959).
Glued botanic
elements: 68 x 51 cm.
Museum of Decorative
Arts, Paris.

Within the vegetal
matter, where a
landscape can be
made out, an animal
emerges: a wooden
donkey.

Dubuffet
The Clock Train
(1965).
Vinyl on paper stuck
to the canvas:
125 x 400 cm.
(in two panels).

Six clocks on wheels
follow each other,
made up of a mosaic
of hatchings. Their
faces don't give the
hour, but can be read
from left to right.
▼

wax, tar, dust and volcanic ash. These materials, recycled, transformed, were rich in visual possibilities. Dubuffet displayed them in series of works with revealing titles: *High Pastes, Materiologies, Celebrations of the earth...*

▲
The Traveller without a Compass (detail).

Seen from close up, the painting forms solid organic reliefs.

He thus attracted the eye, not interested in making something pretty or graceful, only in producing a strong, immediate sensation. Behind the raw materials, the observer discovers an entire world, with its labyrinth landscapes containing neither up nor down, high nor low, populated by dreamlike figures.

"art in the raw" (art brut), or painting without rules

LER DLA CANPANE
SQON NAPELE LEPE
ISAJE...
Read: «L'air de la
campagne. Ce qu'on
appelle le paysage...»
(THER OF TH
CUNTRYSID WUT
WUN CALZ A LAN
SCAP;
Read: "The air of the
countryside. What one
calls a landscape...")
Dubuffet was no
more respectful of the
rules when he wrote
than when he painted!

*A reasonable art!
What a stupid idea!
Art is nothing other
than intoxication
and folly!*
Dubuffet.

The closed space of painting was not sufficient to satisfy the obsession that the Hourloupe had become. Dubuffet soon extended his creation to many other sorts of manifestations. By the end of the 1960s, he was doing very few paintings. He needed another dimension, between sculpture and architecture: this led to his "monument-paintings", in painted polyester. The artist now conceived his work not on the scale of a room in a museum but on that, completely different, of a city, or even the countryside. For this, he created a studio, and surrounded himself with assistants who, following his instructions, helped him carry out his experiments and construct his "environmental sculptures".

from children's drawings to shop signs

Rejecting the traditional forms of art, Dubuffet was interested in what he called the "non-cultural arts" (like urban graffiti or children's drawings") and the "popular arts" – the signs on shops, the decoration of fair build-

*To guide the mind
firmly away from
traditional paths, to
carry it off to a world
where the mechanisms
of habits no longer
operate, where the
blinkers of custom
have been destroyed...
this is what the work
of art should do.*
Dubuffet.

ings, marionette theatres... "Art is always showing up just where you're not expecting it," said Dubuffet. He also wanted to popularise a singular form of art, which he baptised «art brut", or «art in the raw", an art produced for the pleasure of its creators, without any concern for a potential public.

The art of madmen, strange, or unusual individuals, such as the famous postman Cheval, an amateur architect who erected in his garden in Hauterives, in the south of France, an unbelievable miniature palace, that can still be viewed today.

From 1945 on, Dubuffet put together a collection of drawings, paintings, embroideries, assemblages and diverse objects. He founded the Compagnie de l'art brut, to promote and conserve these unorthodox works of art. Exhibited for a long time in Paris, the collection now has its own museum, in Lausanne, in Switzerland.

Gaston Chaissac
(1910–64),
Character with Big Blue Eye (1961).
Fragments of wallpapers outlined with black ink on brown paper: 152 x 64 cm.

By assembling, as he did here, recycled materials, Chaissac often constructed figures with somewhat naïve and anxious expressions, suggestive of totems.
▼

Adolf Wölfli
(1864–1930).
Saint Adolf Wearing Glasses, between the Two Giant Cities of Niess and Mia (1924).
Coloured pencil on paper: 51 x 68 cm.
Collection of Art in the Raw, Lausanne.

In the years that he spent in a psychiatric hospital, Wölfi drew tirelessly. The story of his life, which he calligraphed and ornamented, forms a pile two meters high! Without having ever studied drawing, Wölfli elaborated complex compositions, filled with mysterious signs.
▼

Max Ernst
(1891–1976),
Ubu imperator (1923).
Oil on canvas:
81 x 65 cm.

The mould used to
cast sculptures in
bronze becomes
the body of a large,
hollow character:
Ubu, king of
derision and
fatuity, as described
by his creator,
Alfred Jarry.

▲
Giorgio De Chirico
(1888–1978),
*Premonitory Portrait of
Guillaume Apollinaire*
(1914).
Oil on canvas:
81. 5 x 65 cm.

In 1914, De Chirico
traced this circle on
the temple of his friend
Apollinaire. In 1916,
the poet was critically
wounded by
an exploding shell which
hit him...on the temple.

Raoul Hausmann ▶
(1886–1971),
ABCD (1923–24).
Collage and Indian ink on
paper: 40.4 x 28.2 cm.

The image puts letters
and printed figures on the
same level as the
photographed face of the
artist, who screams into
this visual chaos.

Painting
and the image

From the earliest times, the inventors of images have been artists, painters, engravers... But in the 20th century, new means of making and showing all sorts of images increased. The traditional domain of painters was invaded; they are far from the only ones showing images today. We now live, it is said, in the civilisation of the image. Indeed we are surrounded by them: photos, reproductions, posters, images from the cinema, television, computers.... This profusion has transformed the ways of painters, and also of the public. It has doubtless increased the distance between artists and their public.

The painters, on their side, opened their art to other temptations, to other attractions than that of the image; they already began to do so at the start of the modern period, and even more with the advent of Abstract painting.

As for the public, it observes so many images, everywhere, every day, that nothing can astonish it any longer. Images are so ordinary that the public forgets that they are only an illusion. And that to accept them, to receive them, one needs to possess the singular faculty of imagination.

Of course, all it takes to see a painting is one good look. An image can be read in a glance, or at least it gives this impression. Whether fixed or mobile, all images create a similar problem: they all evoke the mirror's reflection. It is not by chance that Narcissus of ancient mythology died of love for his reflection, the image of another self. Whoever sees himself in a mirror feels the troubling effects of this representation. And each image offers the eye a distant echo of this fascination in the manner in which it captures the attention, is fixed in memory, excites the imagination.

It is probably this effect which has caused the image to be so often associated with magic, religion, and spirituality, and has sometimes meant that those who show images have been seen as magicians, mediums with strange powers.

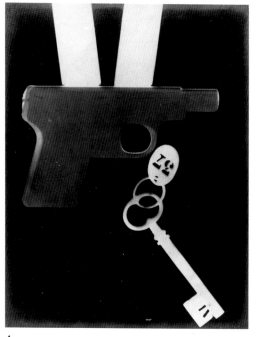

Jasper Johns
(born in 1930),
Figure 5 (1960).
Polished paint
on canvas
and glued
newspaper:
183 x 137.5 cm.
The figure 5 is painted
as if it were a purely
decorative motif with
no meaning.

Man Ray
(1890–1976),
Delicious Meadows
(1922).
Rayogram.

The "rayogram"
(word based on
Man Ray's name)
transformed reality
into images without
any intermediary,
through direct contact
with photosensitive
paper. From the
meeting of several
selected objects a
whole story could
be born.

Jean Hélion
(1904–87),
*The Wrong Way
Round* (1947).
Oil on canvas:
113.5 x 146 cm.

It was only after
practising geometrical
abstraction for ten
years – indicated
by the painting
displayed in the
showcase behind
the central figure –
that Jean Hélion saw
how to paint images
of characters from
everyday life.

Traditionally, in the West, painting creates a privileged link between image and reality, the material, visible world. Over the centuries, the means of this imitation have been transformed. Each pictorial movement has tried to demonstrate its own manner of seeing.

But in the 20th century, photography is the art that definitively took over the representation of the visible. And the painted image decidedly distanced itself from outside reality; it chose to show a reality which was not that of appearances, but which touched on mental images, dreamlike visions, symbolic representations.

Modern painters began to question, one by one, the basic aspects of their art: colour, form, object, materials. They transformed the space of the painting, liberated it from the familiar everyday landmarks. The laws of gravity no longer held sway: up, down, front, back, these concepts no longer had any real meaning.

In this reconquered space, modern art was not only a synonym for Abstract art. Certain painters, like the Expressionists, reinvented new figurative forms. The image became a freer way of looking at the world and its inhabitants.

Some even thought that it could transform the world – with the advent of Soviet socialism or Nazism in Germany, was it not used as an integral part of the propaganda machine?

In the 20th century, the history of the image was marked by two important turning points. In the 1920s, with the Surrealist movement, the image voluntarily eschewed the coherence of reality. It explored the corners of the strange, the depths of human thought, the meanders of the unconscious.

And then, around 1960, came Pop Art - images produced from already known images. The painter borrowed from the daily world its bitterest or silliest clichés, upturning and turning around these visual commonplaces to use as the basis for their creations. For, alongside all other types of images – or because of them – the painted image clearly remained an object of fascination.

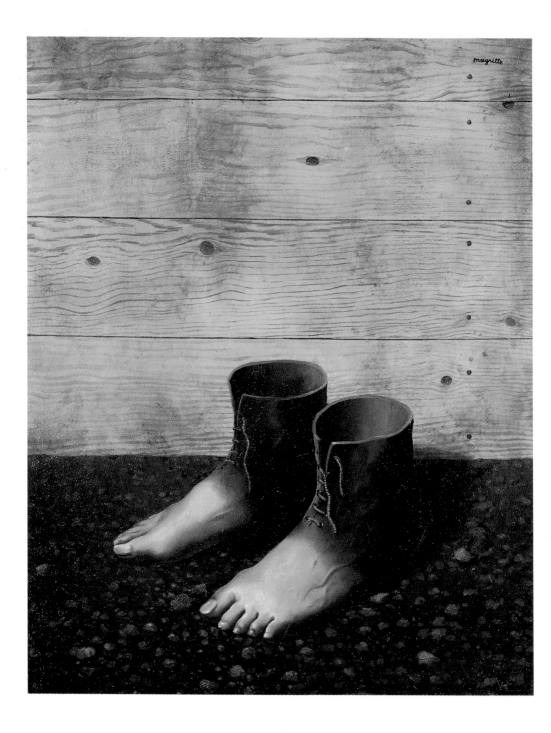

RENÉ MAGRITTE
the literal image

Inventor of images which are familiar and obvious, contradictory and displaced, Magritte meditated on the reality of things and words with an ambiguous humour.

One must obtain an image that defies all logical explanation, and at the same time defies indifference.
Magritte.

Wooden boarding, in the background. The ground covered with pebbles, looking very uncomfortable. And there, set down as if on display at the merchant's stall, are two visual enigmas... the improbable association of feet and shoes in one object.

the wrong foot

The painting's style is impersonal, the colours muted and without particular vibrancy, the light neutral. In short, the technique of the ensemble is not striking, unlike the image itself, which shows something that does not exist. An obvious, logical pairing, or a paradox? Of course, in life, foot and shoe are closely linked. But this daily proximity still does not make them one and the same thing.

Here, through the magic of the image, the foot becomes a shoe and the shoe a foot. Doubt is sown in the comfortable habits of thought of sensible art lovers.

Magritte declared: "The problem of the shoes shows how the most barbarous things can, from force of habit, pass for being altogether acceptable. One feels, thanks to *The Red Model*, that the union of the human foot and a leather shoe is the result of a monstrous custom."

With its calculated contradiction, this image offers a striking demonstration of the mystery of living things, which would become a central theme of Magritte's throughout his artistic career.

◀ **René Magritte**
Belgian painter
(1898–1967),
The Red Model (1935).
Oil on canvas,
mounted on
cardboard:
56 cm high,
46 cm wide.

▲
Clive Barker
(born in 1940),
Homage to Magritte
(1968–69).
Chrome on bronze.

Magritte made ordinary images strange

René Magritte truly found his style around 1924, after having seen Giorgio De Chirico's paintings. When almost all the modern painters were preoccupied with form, he remained faithful to a traditional technique and mode of representation. All that mattered to him was the image, which he painted in a very ordinary way, to make it accessible, at least in appearance.

This is why I paint: to evoke, with unknown images of what is known, the absolute mystery of the visible and the invisible. Magritte.

ambiguous lessons

With his images, which could come straight out of an old schoolbook, Magritte fills, with banal, similar objects – an umbrella, a cup and ball game, a pipe – the interiors of houses, or apparently calm, empty landscapes which take on an eerie feel. By associating images which mingle, all the while contradicting each other, by creating unlikely encounters, the painter produces a surprise effect. The more the relations between the realities shown are telling, yet distant, the more troubling the image is. It is up to the observer, whose sense of logic is challenged, to find his way out of the maze.

Magritte
Le Double Secret
(1927).
Oil on canvas:
114 x 162 cm.

Appearances are a mask which hide an inner emptiness: this is one of the messages of Magritte's bittersweet poetry.
▼

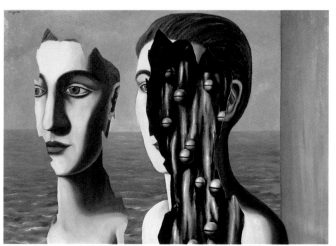

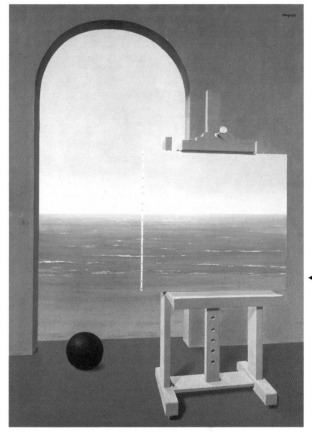

The true value of art is in its liberating power of revelation. Magritte.

◀ **Magritte**
La Condition humaine II (1935).
Oil on canvas:
100 x 73 cm.
Private collection, Geneva.

When the painting seeks and explores the boundaries between reality and representation.

◀ **Magritte**
The Good Example (1953).
Oil on canvas:
46 x 33 cm.

The inscribed caption contradicts the image. And the title contradicts everything! Magritte chose the titles for his paintings very carefully, with the help of friends, to whom he liked to show his finished works. These titles often added an additional enigma to the poetic play of the image.

Magritte liked to say that only painting could make mental images visible: "What one should paint is the image of similarity – if thought is to become visible in the world."

In his paintings, he offered the public that "enormous dose of apparent contradiction" urged by André Breton, the Surrealist movement's rigorous theoretician and promoter, in the *Surrealist Manifesto* of 1924.

For the image makes it possible to present the two most contradictory things together. It says all in one swoop. The meeting of banal bodies and objects with other bodies, other objects, gives the image that singular tone, tinged with humour or eroticism, that Magritte shared with the other Surrealists.

99

Surrealism, or the play of words and images

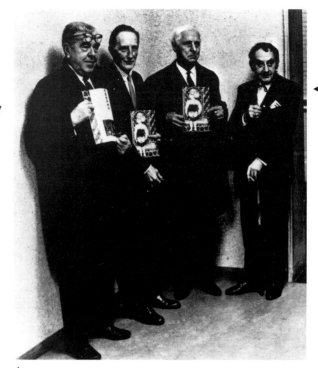

ANDRÉ BRETON

QU'EST-CE QUE LE
SURRÉALISME?

RENÉ HENRIQUEZ, Éditeur

In his native Belgium, Magritte was first influenced by
Dada: in 1925, the result would be the magazine
Esophagus, a review with one single issue! Around 1927,
he met André Breton in Paris. He participated in the
Surrealist exhibitions, but remained somewhat outside
of the group. Their ideas were often different, even if his
painting was to become a reference for Breton.

For the Surrealists, whether they were painters or
poets, the image was the fruit of the psychic forces of
the subconscious, dear to psychoanalytic theory,
whereas Magritte's paintings came from a deliberate
thought process, a reflection, a search for contradiction.
In common with the Surrealists, he was attached to the
notion of social and political commitment. And he had
a talent for reaching a very wide public. Like Breton,
politically speaking, he was receptive to Marxism and
to the hope for freedom which it promised in the midst
of a world in crisis, and soon to be at war.

◄ Illustration by
Magritte for the cover
of *Qu'est-ce que le
surréalisme?* ("What
is Surrealism?")
by André Breton.

Published in 1934,
the book reiterated
the principal theories
of André Breton.
For the cover drawing,
Magritte used an idea
from one of his
paintings, entitled
The Rape.
He often gave several
versions of his images.

Salvador Dali was, with Magritte, one of the best-known Surrealist painters. Doubtless because they both used seemingly traditional images. With his "spontaneous method of irrational knowledge based on the systematic and critical objectivation of insane phenomena", Salvador Dali painted strange visions, associations of objects, deformed bodies.

And yet, in life, Dali and Magritte were as different as could be. With his hat, umbrella, and nondescript coat, Magritte appeared to be an average middle-class citizen, an impression he then subverted. Salvador Dali, on the other hand, whom Breton had named, by anagram, "Avida Dollars", was famous for his provocation, his wild behaviour, his irony. Both men breathed new and original life into the use of the image, and greatly stimulated our everyday imagination.

◀ **Salvador Dali** (1904–90), *(Partial) Hallucination. Six Images of Lenin on a Piano* (1931). Oil on canvas: 114 x 146 cm.

A half-awake vision. While the notes of the score are devoured by, or transformed into, ants, a series of portraits of Lenin runs over the keyboard like a musical scale. Visual, symbolic, enigmatic poetry, without any concern for reality: so many elements in common with dream visions.

101

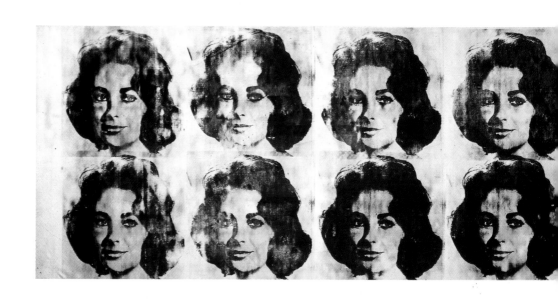

▲

Andy Warhol,
American painter
(1930–87),
Ten Lizzes (1963).
Acrylic painting on
canvas (silk-screen
printing):
2.01 m high,
5.64 m wide.

ANDY WARHOL

the image caught out in its own game

▲
Andy Warhol,
photographed
at c. age 45.

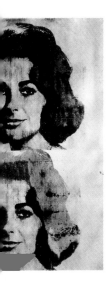

Artist, star, *provocateur*, lucid and cruel genius, Andy Warhol constructed his career as a painter by manipulating images borrowed from the pages of magazines, like this photograph of the movie star Liz Taylor.

Liz, Liz, Liz... Liz Taylor ten times over! In black against a silver grey background, the actress smiles fixedly, or her immobile likeness does. The painting is the size of a big advertising poster, or a panoramic cinema screen.

Which Liz shall we look at first? For, if the portrait itself is the same, each of the ten reproductions is different. On each photo, shadows, stains, overexposure, dirt and other imperfections vary the star's makeup and the overall effect: here, the ink of the development process makes her cry, there it exaggerates her smile, there gives her a moustache, or cuts her face in half.

such a famous smile

Here is the star reduced to her public portrait, multiplied and reproduced endlessly. The observer is troubled: this portrait seems to stop time, as only death can do. The star is imprisoned behind the screen, inaccessible. This is the price of beauty and glory. Liz Taylor is a modern Mona Lisa, a newspaper legend and enigma. Ten Lizzes form a motif, repeated as if on a roll of film, a parade of empty masks, of effigies without depth. Here, it is the repetition which emphasises the fragile, superficial aspect of the image.

If you want to know all there is to know about Andy Warhol, you just have to look at the surface of my paintings, of my films, of myself. There I am. There's nothing underneath. Warhol.

The consummate New Yorker
From the 1960s until his sudden death in 1987, Andy Warhol was in turn advertiser, painter, filmmaker, publisher, author, and producer of shows... Not to mention businessman, *provocateur*, aesthete, and hero of the still fledgling counter-culture.

103

Warhol succumbed to the fascination of images

Differences in prints, stains...The image, an endless source of curiosity, fascinates, in the literal sense of the word. It is a fascination well known to all those who remain glued to the television for hours, or to illustrated newspapers and magazines. Warhol used to say: "I never read; I just look at pictures!" With him, everything ends up having only the depth of a newspaper page.

Warhol's favoured technique was silk-screen printing: a technique used, by definition, to reproduce images in great quantities. Warhol juxtaposed shots, played on effects of smudging, of displacement, of imperfections, parodying the defects in printing so common in the popular press of the sixties.

▲
Andy Warhol at work: Warhol turned the artist's name into a definition, a label, a signature. This *provocateur* claimed that he wanted to do business as much as to create art, in fact that he wanted to make business into an art!

Portraitist of the rich and famous
After his numerous portraits of film stars, Warhol was commissioned to do many portraits of celebrities and rich collectors when they came through New York.

I wish I could invent something like the blue jean. Something that would always be remembered. Something fantastic!
Warhol.

Was Andy Warhol really a painter? By bravado, he constantly repeated that he didn't create his paintings

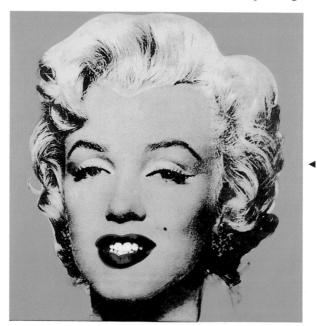

◄ **Warhol**
Turquoise Marilyn (1964).
Silk-screen and acrylic on canvas:
101.6 x 101.2 cm

Andy Warhol presented his own version of the star with the tragic destiny: for him, desire and death were intertwined.

Warhol ▶
The Mona Lisa (1963).
Acrylic on canvas and
silk-screen printing:
319.4 x 208.6 cm.
Blum Hellman Gallery,
New York.

Mocking art and art
history: the famous
Mona Lisa by Leonardo
da Vinci, treated
as though she were
a modern-day star!

*I tried to make them
by hand, but I found
it was easier with
the silk-screen process.
That way, I don't need
to work on the objects
I make. One of my
assistants, or anyone
else, can reproduce the
motif just as well as
I can.*
Warhol.

himself. And it is true that the technique he used didn't
necessitate direct intervention with his own hands.
Serigraphy is a process of reproduction, which takes its
inspiration from the technique of the stencil: one places
the image on a silk screen stretched over a frame. Then,
with a squeegee, or scraper, one passes ink on the screen,
which remains on the silk, having clung to the outlines
of the image.
With a mixture of deliberate clumsiness and of care-
lessness, Warhol determined the background colours
and arranged the images, leaving little place for the
role of emotion.

The Factory
This was the term
used by Andy Warhol
to designate his
workshop. It must
be recognised that
it was a very busy
place... Warhol was
the first one there in
the morning, putting
the ink on the screens,
printing, painting.
Friends who happened
by could add ink for
him when necessary,
following his
instructions. A rock
group might begin
to play. In the
room papered
with aluminium
wallpaper, people
came by to talk,
to drink, to make
films, to develop
photos. The New York
"underground" spent
a good part of the
night there.

105

Pop Art, or when art joins popular culture

Claes Oldenburg
(born in 1929),
Soft Telephone.
Salomon Guggenheim
Museum, New York.

Oldenburg took daily
objects and enlarged
them, using
unexpected materials:
cloth drums,
cardboard sinks
and, here, a soft
plastic telephone.
▼

▲
Warhol
*Cans of Campbell's
Soup* (Chicken
with rice and bean
with bacon) (1962).
Acrylic on canvas:
two panels,
51 x 40.5 cm.
Städtisches Museum,
Abteiberg,
Mönchengladbach.

Consumer products
have become modern
icons. A can of soup
is like a star, an
element among others
in the contemporary
visual universe
of the imaginary.

Stars fascinated Andy Warhol. Liz Taylor, Marilyn Monroe, Marlon Brando and Elvis Presley were so many stars in the firmament of the famous. One could see them, watch them, without ever being able to touch them. They lent the image of their face, of their body, to nourish the collective imagination.

In the America of the sixties, the press, movies, and soon television showed these images. The media were there to inform the public about day to day events. These media were in fact not far from becoming more real than reality: the newspaper page itself is more concrete than the abstract event or the faraway figure it evokes.

the pope of Pop Art

Andy Warhol displaced everyday pictures from the newspaper, or ordinary items found in a supermarket (a bottle of Coca-Cola, a can of soup) to make paintings of them. By bringing pages of advertising or press photos into museums, Warhol integrated them into the world of art works and, in so doing, made people look at them in a different way.

So it was that, from the sixties, Andy Warhol became one of the best-known figures of this new generation of artists which, in England, then in the United States, wanted to create art using the most everyday, popular elements: the generation of Pop Art.

Roy Lichtenstein ▶
(1923–97),
M-Maybe (Picture of a Young Girl) (1965).
Oil on canvas:
152.5 x 152.5 cm.
Ludwig Museum,
Cologne.

Lichtenstein's paintings are smooth and impersonal. His images are large versions of scenes from comic strips and cartoons.

From the comics to the supermarket
Pop Art found its subjects in the everyday, ordinary universe that all could recognise: banal objects, famous figures, scenes from comic strips and, of course, advertising, images of well-known consumer products. Sometimes it could even be difficult to distinguish between a real advertisement and its re-usage by Warhol!

Experimental cinema
In 1965, Andy Warhol announced that he was giving up painting for film, but in fact he didn't. Made in deliberately amateur conditions, with very low budgets, his films were designed to be "experimental". Among them were *Sleep*, filmed in close-up during six hours, which shows a man sleeping, and *Empire*, in which a camera shows the top of the Empire State Building for eight straight hours.

Images from the film *Sleep* (1963). With the authorisation of the Andy Warhol Film Project, Whitney Museum of American Art, New York.

In the film, the image was repeated up to 25 times a second: even more than in the paintings! ▼

In contrast to Abstract painting, Pop Art represented, reproduced, or sometimes actually used familiar and very real objects. Rehabilitating the image, it adopted a "cold" treatment of painting, without a trace of individual expression, thus parodying technology. And, as sculpture, it enlarged in exaggerated fashion industrial mass-produced items.

Its artists consciously infused a note of social criticism into their work. The way they satirized the world and its folly was reminiscent of the approach of one of their precursors, Marcel Duchamp. But isn't critical irony one of the most crucial functions of art?

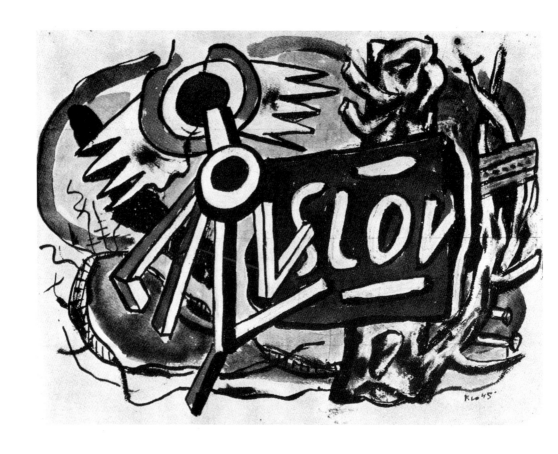

▲
Fernand Léger,
French painter,
illustrator and
engraver
(1881–1955),
*American Landscape
with Red Sign* (1945).

Gouache:
30 cm high,
38 cm wide.
Private collection,
Paris.

Step-by-step analysis

FERNAND LÉGER

▲
Fernand Léger
photographed in 1933,
at the age of 52.

Fernand Léger lived through all the sights and scenes of the 20th century, its wars, its technical transformations, to become one of the most popular of modern painters. He sometimes found himself swept up in the turbulence of the avant-garde. But the force of his personal vision enabled him to develop his work, with no interruption, into a simple and direct style of painting, accessible to all. Strongly influenced by the First World War, he became a witness and chronicler of his times. In this century of the machine, he was a firm advocate of progress. All his work reflects this feeling: by its evocation of the most pedestrian, workaday world, it celebrates with enthusiasm the industrial era and the machine age.

Tempted at one point by the simplification and the geometry of Cubism, Fernand Léger remained faithful to a stylisation of forms – for figures or objects – which made his painting immediately identifiable. His very precise style of drawing, characterised by a thick black stroke, made possible a direct and simple reading of the image.

A preparatory study
The elements illustrated are already in place: the tree, the fencing, the arms of the broken machine. The homage is explicit: one can read: *U.S. Love.* "I painted a series of American landscapes based on the contrast presented by an abandoned machine which has become nothing more than a junk heap, and the flora and fauna it has destroyed," wrote the painter.

A gift from the painter
Fernand Léger donated *Adieu New York* to the MNAM in 1950, simultaneously with several other paintings. With his work in the museum, the painter found a way to see one of his most cherished wishes fulfilled, that of painting for the largest possible public.

modern America

It was in the United States, where he took refuge in 1940, that Fernand Léger undertook his work *Adieu, New York*. Several gouaches and drawings, constituting the series *American Landscapes*, had led up to this major homage to America, "this bold new vertical continent" and to "New York, transparent, translucid, with its "blue, red, and yellow floors", lit up by the coloured neon signs of Broadway and its theatre district.

This American period would free up his use of colour; he had long chosen to paint large surfaces with primary colours treated with flat brushstrokes.

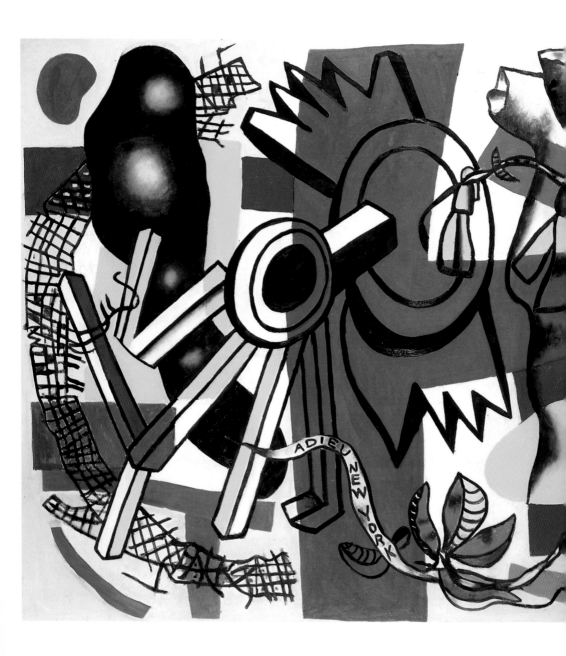

FLEGER

◾ Colour appears in geometrical forms that float across objects like the rays of a coloured projector, like so many banners or standards. In the centre of the painting is a red cross which is missing a branch. The blue surfaces are far behind it. And in the foreground are the greens and the reds, the yellows making luminous puddles devoid of any real shape, or sometimes caught up in bits of the tie or the arms of the machine. This is how Léger freed colour: "by setting it out in large zones, without making it conform to the outlines of the objects: thus it conserves all its power, as does the drawing."

◾ The forms are superimposed and intermingled in a sophisticated composition: the surfaces of colour harmonise among themselves, even as the black stroke describes and defines the outlines. Suspended in space are neckties, leaves, a wheel, pieces of a machine, fencing. A band of white bearing an inscription – ancestor of the comic strip's bubble – floats like a streamer. It carries the caption, which is also the title of the painting: *Adieu New York*.

◾ Because he wished to create art which was direct and accessible to all, because he wanted to illustrate social themes, because he saw himself as only the discreet servant of his images, Fernand Léger did not leave any traces of his brushstroke. This impersonal style sought to approach the simplicity of the printed image.

◾ More or less recognisable, the objects constitute an exploded image of the modern world. In this variegated jumble of wreckage from today's world, the disorder of nature and of the plant universe takes over the space of the painting. Of course, it is no longer easy for us to share the almost naïve enthusiasm of the painter for the century of the machine. But still today, the painting remains a vibrant, energetic emblem of a dynamic world, in which nature has not given up its rights.

◀ **Fernand Léger**
Adieu New York
(1946).
Oil on canvas:
1.30 m wide,
1.62 m high.

Completed in Paris in 1945 (when Léger was 65), the painting is characteristic of the last period of the painter's work. For another ten years, Fernand Léger would make large paintings, but also monumental works such as stained glass windows and mosaics, for French churches, or for the University of Caracas in Venezuela. He thus continued his highly diverse artistic experiences and explorations.

111

Biographical notes

HENRI MATISSE

WASSILY KANDINSKY

French painter born in Cateau-Cambrésis in 1869.

Schooling at Saint-Quentin, then studied at the Law Faculty in Paris; he worked for a lawyer in 1889. He discovered painting during his convalescence after an operation for appendicitis. He began to copy reproductions. In the end, he did not follow his father into the grain business but began to take courses with Gustave Moreau at the École des Beaux-Arts in Paris.

1895-96: his first important works. His style slowly defined itself. He met other painters, collectors. Times were hard until his first exhibition, organised by Ambroise Vollard in 1904.

From 1905 on, with Fauvism, Matisse came to be recognised for his originality. He soon became known internationally. He began to teach in 1908 and continued to experiment and innovate boldly in his painting.

1914: *Interior with Goldfish*. After the war, he would test his discoveries. He concentrated on the human figure, the still life, and interior scenes, with a mastery which soon made him something of a modern classic.

He travelled and lived in the south of France. In 1948, he painted stained glass windows for a chapel. At over 80, he used paper cut-outs to continue to work despite his illness, and produced among other works the magnificent *The Sorrow of the King*.

He died in 1954 in Nice.

His work is on exhibit in all the great museums of the world, from the Hermitage in Russia to the Museum of Modern Art in New York, including Grenoble, the Matisse Museum in Nice, and Cateau-Cambrésis.

Painter born in Moscow in 1866.

From a comfortable Russian upper-class family, Kandinsky studied law and worked as a lawyer. He then held a position as a university professor. At the age of 30, he decided to devote himself exclusively to painting. He took art classes and worked in Munich, in Germany.

In 1901, he founded the Phalanx movement, travelled in Europe and met numerous other painters, in Paris and in Germany. He experimented and innovated in his painting, very conscious of current trends in France as well as of the work of the German Expressionists, but never forgetting Russian popular art.

From 1908 on, he began to follow the path of abstraction. He set up exhibitions, organised artists' groups. He published a text, *Of the Spiritual in Art*, in 1912, which helped make his work known and recognised.

He returned to Russia in 1914 and became involved in the cultural revolution from the beginnings of the Bolshevik Revolution until 1921. He then preferred to come back to Germany to join the Bauhaus movement, from 1923 and 1933. He divided his time between study, teaching, and regular work in his studio.

Fleeing Nazi Germany in 1933, he moved to Neuilly-sur-Seine near Paris. He acquired French nationality when he was over 70, painting all the while. He died quietly during the war, in 1944.

His influence was only recognised after his death, since he was a pioneer of abstraction. His paintings are on view in Germany, in Russia, and in the United States, in particular at the Guggenheim Museum in New York.

YVES KLEIN

PABLO PICASSO

◾ French artist, born in Nice in 1928.

◾ His father was a figurative painter, his mother interested in geometrical abstraction.

◾ He could not enter the Merchant Marine Academy because he did not have his baccalauréat degree. He interrupted his studies in 1946. Soon he discovered judo, which he practised intensely, and the spiritual circle of the Rosicrucians. He began to paint decorative scarves, and to become interested in the idea of the monochrome.

◾ He executed painted handprints, and decorated a site for spiritual meditation. He also practised judo in Japan and Paris.

◾ In 1955, he proposed an orange monochrome to an art gallery which refused it. He was asked to paint a simple black point on it, which would make it into an Abstract painting, but he refused. He hung some monochromes in the judo salon where he taught. He met various artists, gallery owners, and the critic Pierre Restany, who would help make his reputation. His first exhibition was in 1956. Then came several monochrome years, in particular blue ones. In 1960, he painted *Blue Monochrome (IKB 3)*. Fame finally arrived, peppered with scandals and artistic events. He held the exhibition *Le Vide* in 1958, executed paintings using live bodies, made sculptures with fire, and painted with a flame-thrower. He joined the group of the New Realists.

◾ In 1961, he died of a heart attack in Paris.

◾ Klein's works can be seen in several important American museums, as well as in Cologne and in the Tate Gallery in London.

◾ Spanish painter, born in Malaga in 1881.

◾ Pablo Ruiz's father, a painter without great talent, had an ordinary career as a painting teacher. He was teaching in Barcelona when Pablo began his artistic education. Soon, in 1898, Pablo rid himself of the shackles of the overly traditional painting academy in Madrid. He threw himself into life and painting, scraping along on minimal earnings, first in Barcelona and then in Paris.

◾ From 1900, he became known in Paris as an exceptionally gifted young Spanish painter, who had assimilated the lessons of past and present masters. In 1907, with the work leading up to the famous *Demoiselles d'Avignon*, he opened up some decidedly original avenues of exploration. Together, he and Georges Braque invented Cubism, between 1908 and 1912.

◾ Throughout his life, he went through radically different stylistic periods, demonstrating a creative energy which made him a truly exceptional figure. Two constant themes which never ceased to interest him during the most diverse periods of his development were: the female body and painters of the past.

◾ He died, world famous, in 1973, in Mougins in the south of France, almost without having slowed down his production, despite his age (90).

◾ Picasso's output was so considerable that his paintings can be found everywhere, especially, of course, in the two museums which are exclusively devoted to him, in Paris (more than 200 paintings and 150 sculptures) and in Barcelona.

113

LUIGI RUSSOLO

PIET MONDRIAN

▨ Italian musician and painter, born in 1885 in Portogruaro.

▨ Luigi Russolo was born into a family of musicians. After demonstrating a passing interest for music, he turned to painting, in a Symbolist vein. He held his first exhibition in 1909 in Milan.

▨ He met Boccioni and together they joined the burgeoning Futurist movement in 1910. Very active in the movement, he participated in all its artistic manifestations and put the key preoccupations of the Futurists into practice in his painting, in particular the expression of motion. In 1912-13, he executed his master work: *The Power of an Automobile*. He remained close to Boccionni, de Carrà and Severini.

▨ In 1913, he published the manifesto *The Art of Sounds*, on the usage of sound-noise. Soon after this, he began to construct his instruments, the *intonarumori*. He played in Italy and was welcomed enthusiastically in Paris in 1921, when he played for Stravinsky, Ravel, Milhaud, Paul Claudel and... Piet Mondrian.

▨ Fascism, which he refused, excluded Russolo from Futurism little by little. He continued to do music of accompaniment for Futurist films, then little by little gave up music out of discouragement. He died in 1947 in Cerro di Laveno, having ceased all artistic activitiy.

▨ A fairly small number of his paintings are well known, dispersed between Basel, The Hague, Milan, Grenoble and the Museum of Modern Art in New York. As for his instruments, which produced music that was forty years ahead of its time, they have almost completely disappeared.

▨ A Dutch painter, born in Amersfoort in 1872.

▨ He decided very young to become a painter, and got a job early on as a professor of drawing, recommended by his father who was a teacher. In 1892 he received his degree, and soon gave up teaching and spent time in several academies, making copies of the masters and doing portraits to earn a living. He travelled, and became interested in the spiritualist philosophy of the theosophists.

▨ After colour, the schematisation of forms was one of his preoccupations when he discovered Cubism around 1912, just after his first exhibition in Amsterdam. He painted simplified Dutch landscapes, using the signs + and -. Flat surface brushstrokes and colours were soon inserted into geometrical structures. In 1917, he founded along with the painter and essayist, Van Doesburg; the sculptor, Vantongerloo; and the architect, Rietveld, the avant-garde review and artistic movement called *De Stijl*.

▨ Very austere in his work, Mondrian patiently developed a cold, geometrical style of painting. He wanted to reconstruct the world and man according to new, pure rules. He formulated the rules of Neo-Plasticism, around 1920, when he was living in Paris. He was part of the Circle-Square group, then Abstraction-Creation, between 1930 and 1936. In 1937, he painted *Composition II*. His contemporaries were struck with the economy of his painting, the severity of his explorations.

▨ He left for New York just before the Second World War, and died there in 1944, the same year as Kandinsky.

▨ His works can be seen in Holland, at the Stedelijk Museum in Amsterdam and in the Gemeentemuseum of The Hague, as well as at the Museum of Modern Art in New York.

FRANCIS PICABIA

JACKSON POLLOCK

▪ Painter, illustrator, and writer, born in Paris in 1879.

▪ Because Francis was very precocious, his father sent one of his paintings to a Salon, which accepted it and gave it an award. He soon was studying at the École des arts décoratifs, then taking courses at the École du Louvre.

▪ A first career was opening before him. He painted, "*a young painter in an already old movement*", as he was to say, in a late Neo-Impressionist style which pleased the public. By 1905 he was already successful. But from 1908 on, he began to have doubts about this facile painting, from which he was learning nothing. Free to do as he liked thanks to a private fortune, he set out in a career that would be filled with stops and starts and about-faces in style and direction, often disconcerting his own friends.

▪ Spain, New York: Picabia travelled and met Duchamp. For years they would work side by side. Prefiguring the Dada movement, Picabia disregarded all the rules. He quickly went beyond Cubism, painted hastily copied machines, and published poetry. He joined the Dadaists in 1919 only to leave them three years later. In 1921, he painted *Tabac-Rat*. His attitude left many perplexed. His style was sometimes Abstract, sometimes almost laboriously realistic. He often had recourse to collage, to the assemblage of materials, as of images. He lived a life of luxury, had a passion for fine cars, and an existence characterised by a certain disorder and carelessness.

▪ He lived through the war without, it would seem, being too deeply affected by it, and painted Abstract works for nearly ten years. He died in Paris in 1953.

▪ His works can be seen in the United States, in the Moderna Museet of Stockholm and in the MNAM.

▪ A child of the American Far West, Pollock was born in 1912 in Cody, Wyoming, into a simple family.

▪ He studied art near Los Angeles, then in New York. He was familiar with the art of the Navajo Indians who painted on the ground with sand. He learned mural painting on a large scale, as Mexican artists practice it traditionally. During the Depression years, from 1929 until the Second World War, he restored monumental paintings on public edifices.

▪ He was discovered in 1942 by the gallery owner and collector Peggy Guggenheim. He became a hero of American art when he painted his "drippings", and was considered to be the most important of the Abstract Expressionists. Success did not cure his existential angst; he drank heavily and ruined his health.

▪ The truly productive and innovative years of his career did not last long, only from about 1945 to 1950. In 1948, he produced *Number 26 A Black and White*. The labyrinth of drippings gave way once again to images around 1952.

▪ Pollock died in a car accident in 1956 in Long Island, near New York.

▪ The most important representative of action painting in the United States, he embodied the myth of the tortured painter, the creative artist with a tragic destiny.

▪ American museums often exhibit his works, the Museum of Modern Art in particular, but his paintings can also be found at the Tate Gallery in London and the Guggenheim Foundation in Venice.

JEAN DUBUFFET

RENÉ MAGRITTE

French painter, illustrator, sculptor and writer, born in 1901 in Le Havre.

He studied at the École des Beaux-arts of his native town but felt that it was no longer possible to create art in the West, so heavy was the weight of the past, of tradition. Around 1925, he gave up and took over the business of his father, a wine merchant. In 1933, he again began to paint, and again gave it up in 1937.

It was only in 1944 that he finally made his real début in the art world. His exhibitions provoked controversy. Some people saw in his creations the work of a charlatan. Dubuffet painted with a wild, ironic verve, in a manner reminiscent of children's drawings, and was very attentive to the materials used.

From then on, he never stopped painting, with several quite distinct periods, which bear the titles of series and for which he kept a precise catalogue: the portraits of *More Beautiful Than They Think (1947)*, *Grotesque Landscapes*, *Beards*, *Materiologies*, *Beaten Pastes*, in the 1950s. In 1949 was the first exhibition of the "art in the raw" collection. 1952 saw *The Traveller without a Compass*. After the period of the Hourloupe, with its singular graphism, from 1967 on he produced only monumental sculptures. He then set up a studio to help execute his works.

He died in 1985 in Paris.

There are works by Dubuffet in the world's important museums, in particular in the Museum of Decorative Arts in Paris, which received a donation from the artist. But his public sculptures can also be seen, in Flaine, in New York, in Issy-les-Moulineaux.

A Belgian painter, born in Lessines (in the Hainaut) in 1898.

Magritte came from a simple, somewhat unstable family, marked by the death of his mother. Magritte's schooling was ordinary. He started to paint towards the age of 16, and studied at the fine arts school in Brussels, as well as private academies. He began to frequent European artistic circles.

He exhibited his first paintings in 1920. He soon was earning a living, with difficulty, as a graphic artist in advertising. In 1926, with the *Lost Jockey*, Magritte found his style. Technically and aesthetically, he was to remain faithful to his choices until the end of his career. Between Brussels and Paris, he entered into contact with artists of the Surrealist group. He spent time with poets and painters. He regularly produced images which, he hoped, were a reflection of thought.

In 1928, he participated in the Surrealist Exhibition, all the while defending his independence. He soon became famous as a Surrealist painter, recognised by a wide public, even though his relations with the movement and with its creator, André Breton, were stormy. In 1935, he produced *The Red Model*. He continued to organise exhibitions, subversive activities and provocations, for which he had a special talent, kept hidden under his apparently ordinary appearance, similar to that of the character with the bowler hat in his paintings. After the war, the irony of his painting become increasingly cruel and cynical.

He died in Brussels in 1967. A retrospective of his work had just opened its doors in Rotterdam ten days earlier.

Associated with Surrealism, his works can be found in many museums in America and Europe.

ANDY WARHOL

FERNAND LÉGER

▨ An American artist, born in 1928 in Pittsburgh.

▨ The son of Czech immigrants, Andrew was a well-behaved, somewhat puny schoolboy. He studied graphic design and showed remarkable invention and style. He obtained his degree in 1949.

▨ He went to New York and began a first career as a graphic designer in advertising; success came in less than ten years. But in 1960, he decided to become an artist. His first canvases were comic strip scenes, which he exhibited in the window of a New York department store.

▨ In 1962, he held his first exhibitions: startling and original, they provoked scandal. In 1963, he produced his *Ten Lizzes* and became the leading representative of American Pop Art. His studio was soon a meeting place of the New York art scene. In 1964, he announced his intention of giving up painting to make films. He was a publisher and a producer of theatre, shows, and rock musicians. In 1968, he survived an assassination attempt.

▨ In 1972, he executed a series of portraits of Mao Tse-tung. He did many portraits of celebrities the world over. He himself became rich and famous. This son of an immigrant worker had succeeded in getting his revenge on the world.

▨ In 1987 he died during an operation.

▨ American museums have many works by Warhol, especially in Pittsburgh, where he was born, and which has a museum devoted to him. Other works are represented in European collections, such as the Saatchi Collection in London or the Ludwig in Cologne.

▨ French painter born in Argentan in 1881.

▨ Working as an illustrator for an architect in Caen, then in Paris, around 1900, he studied in several academies, and met many artists. He was influenced by the Cézanne exhibition of 1904 and the Fauve exhibition of 1909, before being attracted by Cubism.

▨ With the *Contrasts of Forms* around 1913, his painting followed a geometrical simplification. He was close to Apollinaire, Cendrars, Robert Delaunay. The war in 1914, from which he returned home wounded, was a great shock. Taking his images from the real world, he began to portray stylised scenes showing machines and mechanical apparatus, peopled with human figures.

▨ He wanted to create monumental paintings to improve the urban landscape. He also dabbled in cinema around 1924. The simplicity and architectural precision of his painting made him an instant classic, independent of, but not insensible to, the various artistic movements of the century. In 1930, then again during the Second World War, he was to confront his taste for the modernism of the contemporary world and America's technological progress. On his return, in 1946, he created *Adieu New York*.

▨ Always concerned with the realities of his age, he joined the Communist Party for a time and executed, in the 1950s, monumental paintings for churches and public buildings, such as the University of Caracas in 1954. He died in Gif-sur-Yvette in 1955.

▨ America and Europe both have many of his works. The Museum of Biot is devoted exclusively to his art, and the MNAM has 35 of his paintings.

A century of artistic movements: 1860–1960

New Figuration ...1960--

New Realism 1960--

Pop Art 1955---------

Art in the Raw...1949..................

Informal Art ...1950----1960...

Abstract Expressionism ...1945---------1960...

Abstraction-Creation ...1931---1936

Surrealism 1924-----------------------------1960

Socialist Realism 1922---.....................................

International Style 1920------------------1939...............

Bauhaus 1919--------------1933...........................

Constructivism ...1918---------1924......................

Neo-Plasticism 1917--------------1925.................

Dada ...1916-----------------1924...............

Suprematism ...1915--------------------1924..............

Art Deco ...1912-----------------------------1930..........

Futurism 1909 --------------- 1918

Cubism 1907-----1914

Fauvism 1900---1907.....

Art Nouveau 1890---1905...

Expressionism ...1890--- 1925...............

Symbolism ...1880-----1900.......

Impressionism .1860----1880....................

Realism .1855...1960...

Movements, schools, and tendencies

Realism: 1855–70.

In the narrow sense, a doctrine shared by painters and writers of the middle of the 19th century, in reaction to Romanticism. The Realists were interested in the real and tangible aspect of things, wanted to show life in all its reality, and were preoccupied with the social significance of their art. In literature, Balzac and Zola represented this approach.
Artists: Courbet, Millet, Daumier.

Impressionism: 1860–80.

A movement constituted to organise exhibitions, and a pictorial technique that appeared in the second half of the 19th century. Determined though misunderstood, the Impressionists managed to impose their point of view in the long run, on most of the issues they had raised. By decomposing light into colours, they developed a new vision of the world, which no longer needed traditional perspective and no longer sought the illusionist touch.
Artists: Monet, Degas, Pissarro, Renoir.

Symbolism: 1880–1900.

An artistic movement founded by a free association of artists at the end of the 19th century, in reaction both to Impressionism and to Realism. The Symbolist painters sought to translate and evoke mystical ideas and sentiments, rather than to imitate or reproduce objects with precision.
Artists: Moreau, Odilon Redon, Khnopff, Klimt.

Expressionism: 1890–1925.

Artistic tendency which reached its apogee around the First World War, in particular in the north of Europe and in Germany. Munch, Van Gogh, and Ensor were its precursors. Various other artists recognised and identified with, in their work, the primacy of a vision exalting emotion and sensations above all else, and translated this with an exaggeration of the stroke and the use of vivid colours. The painter proposed a deformed and expressive vision of the world.
Artists: Kirchner, Jawlensky, Grosz, Dix.

Art Nouveau: 1890–1905.

The name Art Nouveau grouped together a number of different styles (the "noodle" style, the "modern style". etc.) all relating to the decorative arts and architecture,

and characterised by an ornamental and decorative tendency which celebrated the line and the arabesque, borrowed from vegetal forms, and saw in ornamentation the sign of the structure of objects or architectures. The Art Nouveau movement brought about important transformations in the graphic arts and in the conception of images, for instance in the art of the poster. All the innovative painters of the time were influenced by it.

Fauvism: 1900–07

The term Fauvism first appeared in 1905, but the tendency that it described had already existed for several years. With Matisse at their centre, this group of painters was involved in a collective phase of exploration, which involved a liberal use of colour and a vigorous brushstroke. The overall influence of the Fauves was far greater than the size of the original group itself would have led one to believe.
Artists: Matisse, Derain, Vlaminck, Van Dongen.

Cubism: 1907–14.

A major aesthetic revolution, which would mark the entire century, first came into existence around 1907 but only was familiar to the public from about 1911 on. Motivated by a central concern with discipline and purity, the Cubists sought to construct volume through coloured surfaces, and to represent objects in function of their permanent formal qualities. The transformation of objects through geometrical simplification resulted in a certain form of abstraction.
Artists: Picasso, Braque, Gris, Léger.

Futurism: 1909–18.

A movement of artistic militancy founded in 1909 by the poet Marinetti. He preached the virtues of the machine age and speed, in an affirmation of the optimism of modernity and a rejection of tradition. After the war, the movement had very wide and contradictory social and political repercussions. In painting, a chief characteristic of this school was the repetition of the image used to create a sense of motion.
Artists: Carrà, Russolo, Boccioni, Severini.

Art Deco: 1912–30.

The Art Deco style, nourished by the discoveries of the Cubists in particular, is a simplification of the modern style. It is a renewal, without revolution, of constructed forms, recognisable by its purity, the stylisation of its lines, and its decorative motifs that tended towards the geometric. The Exposition des Arts décoratifs in 1925 gave the movement its name.

Suprematism: 1915–24.

A theory which radicalised the Cubist experience of the Russian painter and theoretician Kasimir Malevich. His goal was to reinvent the painted figure using elementary geometrical forms. In this radical questioning of the rules of painting, the avant-garde spirit is illustrated in an exemplary manner.

Dada: 1916–24.

An artistic movement of poets and painters, which was born in various corners of Europe in reaction to the First World War, and which aimed at creating a kind of anti-art, at questioning and mocking all the established values in the arts; indeed, in all areas of life. The freedom they demanded led them to invent new solutions, such as the collage and the ready-made.
Artists: Duchamp, Picabia, Hausmann, Schwitters.

Neo-Plasticism: 1917–25.

A doctrine expounded in the review De Stijl, based on Mondrian's theories, calling for a strict geometrical simplification of painting into vertical and horizontal forms, applied to painting but also to architecture. Its influence would soon reach far beyond the De Stijl group.

Constructivism: 1918–24.

A Russian movement which, after Cubism and Futurism, sought to develop a rational, architectural art, attentive to social needs. It influenced geometrical painting and industrial design.
Artists: Tatlin, El Lissitsky, Rodtchenko, Pevsner.

Bauhaus: 1919–33.

A German school of drawing and architecture. The name does not define a style but the work methods and concepts elaborated by numerous artists of varying origins, who found in the movement the opportunity to theorise about their work and to help make it better known. The artists of the group worked on forms and materials that

were adapted to modern times. The philosophy of the Bauhaus influenced not only art, but also industrial design, architecture with Walter Gropius, and the pedagogy of art.
Artists: Kandinsky, Klee, Albers, Moholy-Nagy.

International Style: 1920–39.

In architecture, a rationalist approach that eliminated the decorative in favour of the functional, using new materials such as concrete.
Artists: Le Corbusier, Van der Rohe, Wright.

Socialist Realism: 1922–1960.

A Soviet artistic doctrine which wanted to give a social sense to painting by making it illustrate political and social problems, with an ideological mission, and an illusionist and traditional pictorial treatment. This movement eliminated the other truly modernist aspects of art in the U.S.S.R.

Surrealism: 1924–60.

A movement which, led by André Breton, united artists interested in the exploration of the unconscious and who continued, as the Dadaists had, to demand freedom in their choice of methods. Along with poetry, politics, and psychoanalysis, painting played a central role. This was one of the most important artistic movements of the century, influencing a great number of artists.
Artists: De Chirico, Miró, Dali, Magritte.

Abstraction-Creation: 1931–36.

An international artistic association founded in Paris, which united most of the Abstract painters, of all schools, in order to organise exhibitions and challenge the influence of Surrealism.
Artists: Vantongerloo, Herbin, Kupka, Gleizes.

Abstract Expressionism: 1945–60.

Term applied to the Abstract American painters who shared a desire to express their own personal lyricism through gesture or colour, with no concern for representation of the outside world. Various tendencies existed within the movement, known as The New York School, action painting, or gestural painting.
Artists: Pollock, de Kooning, Motherwell, Kline.

Informal Art: 1950–60.

A tendency, at the end of the Second World War, shared by a number of Abstract painters linked with the School of Paris, in reaction against the American painting of the time. They were interested in the use of stains, of various materials, of the calligraphic symbol, as direct expressions of the painter.
Artists: Mathieu, Fautrier, Michaux, Dubuffet.

Art in the Raw (art brut): a general tendency in art, given a name in 1949.

It was Jean Dubuffet who suggested this name when he brought together creations that up until then had not been considered works of art. These might include, for example, the work of madmen, naïve painters, those who used the means of expression of the visual arts not with the intention of creating Art but simply to express themselves, with no pre-established rules, with no concern for cultural conventions. This was a form of art which, without being given a name, had always existed.
Artists: Wölfli, Lesage, Aloïse, Soutter.

Pop Art: 1955–70.

Movement that began in the early 1950s in England. Pop Art became principally an American phenomenon from the 1960s on. It was a spirit rather than a style, and consisted in showing the reality of modern times and the consumer society by introducing into art works various objects and signs drawn from daily life, using as materials the media, and commercial and industrial products.
Artists: Warhol, Lichtenstein, Rosenquist, Oldenburg.

New Realism: 1960–70.

French movement which sought a new expressivity and new perceptions by appropriating fragments of reality, and by giving meaning to recycled materials, often arranging them in collages and assemblages. New Realism was a European trend in parallel with Pop Art.
Artists: César, Tinguely, Sperri, Klein.

New Figuration: 1960 to the present.

General European tendency which played an important role in the 1960s when abstraction was losing ground and the image was coming back into its own in painting, creating new relations between the artist, cultural signs, and social reality.

Glossary

Abstraction

A manner of conceiving of forms and figures not by imitating a visual image, but through a projection of the mind or spirit. Geometrical forms are an example of this tendency.

All over

An American term designating a form of frontal composition in which the pictorial elements are spread out equally over the entire surface, even appearing to extend beyond the edges of the canvas. This principle is often at work in the painting of Pollock, Klein, and Mondrian.

Assemblage

A collage of elements or objects in volume, somewhere between a painting and a sculpture.

Automatism

Method of drawing in which the pen wanders with no precise purpose, letting unconscious inspiration take over.

Bas-relief

In sculpture, when the sculpted volumes emerge from a surface, jut out from it. With the advent of the collage and the assemblage, the differences between painting and sculpture disappeared.

Binder

Product used to bind the pigments of a paint.

Brushstroke

The way the colour is applied, the trace of the brushstroke which gives its particular character to the painting.

Charcoal

Wood (from the spindle-tree) transformed into charcoal which is used as an instrument, like a pencil, for drawing. The Cubists employed it to create shadows.

Chiaroscuro

In a painting, the balance between light and shadow to create an effect of depth, an illusion of volume.

Chromatic

From *chromos*, a Greek word designating colour. That which belongs to colour.

Chronophotography

Photographic process allowing one to decompose movement, an ancestor of the motion picture camera and projector. J.-B. Marrey was one of the pioneers of this process around 1892.

Collage

A technique consisting of sticking papers, cloth, or other materials to the surface of the canvas and arranging them.

Colours

The three primary colours, blue, red and yellow, are at the base of all the others, which are obtained through mixtures. They are pure when unmixed, more muted when black is added to them.

Composition

The organisation, architecture, arrangement of the forms and colours on the surface of a painting.

Decorative

Sign or form which has no other meaning than itself, whose only function is ornamental.

Dripping

An American term, which comes from *drop*, and *drip*. A process consisting of letting the colour drip along a stick placed horizontally across a perforated can of paint (Pollock).

Enamel

Industrial paint, which painters have used for their own purposes to paint with paint guns or to obtain particular effects from certain materials.

Figurative

In ordinary language, is often used in opposition to "abstract".

Figure

Identifiable form, autonomous, which can be analogous, resembling an object or a real body, but one will also speak of a figure in relation to geometrical forms. In painting, the figure is opposed to the background, when it is an isolated motif.

But the moderns expanded the meaning of this word. One must not, in any case, limit the idea of the figure only to representations of an outside reality.

Flat colour

A way of deposing colour uniformly, without leaving brush marks or giving any shading to the coloured surface.

Format

The real dimensions of a painting are a key element in how it is perceived. This must be kept in mind when one sees reproductions in the pages of art books!

Frame

Piece added to the painting to define its boundaries. The moderns often prefer to do without it. The frame is also, for the photographer and for the painter by extension, the definition of the space taken up by the image, which must be determined with each image.

Hanging

The act of fixing the paintings on the wall, and more generally of arranging judiciously an artist's work in an exhibition hall or room.

Hatchings

Effects of shadow created using parallel lines.

Illusionism

Technique which deceives the eye by making it believe that it sees a real object rather than its representation by the artist.

Landscape

The word is no longer reserved for the reproduction of a real landscape. In a figurative sense, one can speak of a mental landscape, implying that one sees what is taking place in the mind or spirit.

Line

An unbroken line, visible or virtual, which the eye follows. The line leads, gives a direction, at the same time as it separates and divides the surface.

Local tone

This is the colour of real objects, as ordinarily perceived. In the course of the century, painters were to pay less and less attention to the colour of reality, but to choose the colours of the painting for the effect they were seeking.

Manner

Each artist's individual style that characterises a work, resulting from an ensemble of processes used.

Material

Paint is a material whose principle characteristics are malleability, colour, smoothness, fluidity, capacity to dry, to mix with other materials, to remain stable over time.

Monochrome

Painting executed in one single colour.

Object

Artists became interested in objects from everyday life, which would make their entrance into the work of art either through representation or even actual insertion into the work itself.

Oil Painting

Paint constituted of crushed colours, mixed with oil, which becomes thick and transparent as it dries. This has been the traditional technique of painters since the 15th century.

Palette

The surface on which an artist places his colours while he works. Also designates the ensemble of colours used by a painter for a given painting.

Photography

Its appearance in the course of the 19th century – officially in 1839 – changed the function of painting. It represents more rapidly and faithfully what the eye perceives in the outside world than do the painter's sustained efforts!

Pictorial plane

The plane of the painting, which is situated directly behind the frame, and separates the spectator's domain from that of the painting.

Pigment

Any substance which, when mixed with a liquid, creates a colour which can be used to paint.

Portrait

A traditional type of painting, transformed by modern painters. One no longer does portraits purely in function

of the subject's appearance, but by using other means, to evoke personality, colours, materials.

Preparation
The materials used to ensure that the surface to be painted is ready to receive and fix the pigment or various pictorial materials.

Ready-made
An American term. Marcel Duchamp gave this name to a kind of work he invented, which consisted in taking an ordinary object and displaying it as a work, a "ready-made" work. Many other artists would use and vary this principle.

Running
Trace of painting which has escaped from the painter's control and run over the surface of the canvas. This technique implies both the artist's detachment in relation to traditional rules of the craft, and the vertical position of the painting.

Serigraphy (Silk-Screen Printing)
A technique of semi-mechanical reproduction, which allows one to print an image by painting across a silk screen whose mesh designs a form, an image, in function of the degree of obstruction. With this process, one can make several copies of the same image simultaneously.

Simultaneous contrast
An optical law according to which the eye perceives as white several juxtaposed colours. It synthesizes incoming information on colours, those of the solar spectrum, into white light.

Space
In paintings, there is an illusion that the observer accepts. The evocation of traditional space is linked to perspective, which makes the painting the fictive equivalent of a window. But the colour, the forms, the lines also organise a space which is specific and readable. Moreover, the moderns play on concrete space, the environment where the observer is standing.

Stain
As opposed to the line, and containing colour. It is an extended surface, with no direction, but with a shape.

Stretcher
The wooden frame across which the canvas to be painted is stretched and attached.

Support
Modern paintings are no longer all painted on canvas with a backing. Any material can nowadays be used as a support for a painting: a board, an object...

Thickening
Describes the state of the paint when it is accumulated in visible layers.

Ultramarine
A pigment traditionally made by crushing lapis-lazuli, a semi-precious stone, which has always been expensive and highly valued.

Value
When speaking of a colour, this is the degree of intensity of a tone, in relation to shadow and light. When speaking of a work of art, this refers to an estimation of its price on the market.

Vernissage
The French term for an art show opening or preview, the word refers back to the time when paintings were varnished, which represented the last stage before unveiling them to the public. But the inauguration of an exhibition remains an important event.

Watercolour
Light, luminous painting, usually done quickly, with the paint applied on paper or cardboard, more transparent than gouache in its colouring effects.

Work
Each of the pieces produced by an artist, but also the ensemble of an artist's creations.

Writing
By analogy with a written manuscript, is used to describe one of the aspects of the style, to specify the quality of the traces of the painter's gestures, his "touch" or brush-stroke, as used to be said when artists all painted with brushes, and what this expresses. For instance: a clear, tense writing. A supple, thick writing.

Photographic credits

Layout and composition: Thierry Renard
Graphic concept: Maxence Scherf
Copy-editing: Christine Schultz-Touge
Photoengraving: Daïchi, Singapore
Printed by Arti Grafiche Gajani, Rozzano - Milan
Copyright registered November 1999